IMAGES
of America

WINERIES OF SANTA CLARA VALLEY

IMAGES
of America

WINERIES OF SANTA CLARA VALLEY

Bev Stenehjem

ARCADIA
PUBLISHING

Published by Arcadia Publishing
Charleston, South Carolina

Printed in the United States of America

Library of Congress Control Number: 2014954963

For all general information, please contact Arcadia Publishing:
Telephone 843-853-2070
Fax 843-853-0044
E-mail sales@arcadiapublishing.com
For customer service and orders:
Toll-Free 1-888-313-2665

Visit us on the Internet at www.arcadiapublishing.com

For Mark, Tara, Lindsey, Sarah, Allan, and Ella

CONTENTS

Foreword 6

Acknowledgments 7

Introduction 9

1. Guglielmo Winery 11

2. Ross Vineyards and Winery 25

3. Hecker Pass Winery 43

4. Fernwood Cellars 57

5. Solis Winery 73

6. Fortino Winery 87

7. Morgan Hill Cellars 99

8. Kirigin Cellars 115

FOREWORD

The art of winemaking may have been in existence for over 6,000 years. Just 44 years ago, I thought it was a very good idea to join the relative handful of people who had chosen this craft as their lives' work. In 1971, almost all of the people engaged in winegrowing were born into it. I was among the first of the newcomers to establish a winery and work side by side with the distinguished and famous vintners of the time. There were fewer than 200 wineries in California in 1971; a couple of dozen had achieved national prominence and the rest served the needs of local and regional consumer demand.

During my 40-some years of winemaking, wine quality, overall, has improved enormously, and the scientific body of knowledge about viticulture and enology has surpassed what had been learned in the past six millennia. The irony is, that with all that is now known, the goal seems to be to recreate the aromas and flavors of the classic wines of the past. There is nothing new under the sun as the saying goes, and that is especially true about wine. But every person entering this potentially ennobling profession fervently believes they have something to offer.

I met Bev a few years ago, around the time she had begun writing a wine column for a local newspaper. As she is one of the most astute wine writers of present times, she quickly realized the real story is not just about the wine, it is about the people making the wine. What were their motivations to either enter the business or continue a family tradition? This is the real story.

Here are the stories of eight families of the greatest traditions in the oldest winegrowing region in the United States. It is no easy task to turn back the cover and allow us a glimpse into the fascinating history of the special people who have chosen winegrowing as their way of life. Bev has provided us this opportunity.

—Thomas Kruse
Founder, Thomas Kruse Winery

ACKNOWLEDGMENTS

This book would not be possible without the help of the children, grandchildren, and great-grandchildren who climbed into musty attics and rifled through packed-away boxes to find the treasures of their family photographs. It was not always easy for them to find the photographs in their own homes, which required them to place calls to their remaining relatives, some living in other states, in hopes of tracking down some of these cherished images.

It was an honor and a privilege to talk to all these descendants, some of whom are now in their 70s and 80s. They were beyond generous in giving me their time to recount the stories that they remembered about their ancestors and editing the captions for accuracy. These stories, in the form of captions that correlate with each photograph, are stories that needed to be told. As far as anyone knows, this is the first time that a historical accounting of this nature has been done on behalf of our wineries in Santa Clara Valley.

I appreciate the very special opportunity I was given to have a glimpse into the lives of people from past generations. One highlight of my experience includes holding the actual pan that Charles Sanders (the original property owner of Fernwood Cellars) used to pan for gold in 1849, saved and preserved by his great-granddaughter. Another highlight was at the Guglielmo Winery, where I viewed the secret basement used for winemaking during Prohibition.

While I was working on each chapter, viewing the old photographs and looking over my interview notes about each family, I felt a kinship with these ancestors—as if they were alive again and going about their business in this world. I felt a deep sadness when I wrote about their deaths.

My sincere gratitude goes out to the families who shared their photographs and stories—for without them and their efforts, this book would not have been possible.

Thank you to George, Gene, and Gary Guglielmo, the owners of Guglielmo Winery, for sharing memories and photographs of their family and also for the generous gifts of delightful claret.

Thank you to Judy and Jerry Ross, the owners of Ross Vineyards and Winery, and Jim, their grandson and tasting room manager, for the hours of entertaining stories of the Coffe family and the gifts of delicious wine.

Thank you to Mario Fortino and his son Carlo, the owners of Hecker Pass Winery, for sharing their family's photographs, history, and one of the last remaining copies of their family's treasured recipe book.

Thank you to Maryclaire and Mike Sampognaro, the owners of Morgan Hill Cellars, who put me in touch with the previous owners, the Pedrizzetti family. Thank you to Ernesto Pavese, for supplying the well-preserved photographs and stories of his grandfather Camillo Colombano, who was the original founder of the winery. Thank you to Janey Muirhead, daughter of Ed and Phyllis Pedrizzetti, who, in addition to providing the photographs and stories from the Pedrizzetti era of the winery, became a sweet friend along the way.

Thank you to Linda Pond, great-granddaughter of Charles and Annis Sanders, the original landowners of Fernwood Cellars. She provided photographs and stories on behalf of her son Matt

Oetinger. It was such an honor to touch and hold Charles Sanders's gold pan and Annis Sanders's tiny, leather-bound diary.

Thank you to Ernest Fortino, founder of Fortino Winery, and his son and current owner Gino Fortino, for providing photographs and stories, gifts of Charbono, and especially the home-garden tour and handpicked bag of luscious figs.

Thank you to Vic and Michael Vanni, the owners of Solis Winery, for providing photographs and stories of the winery and the Roseo, one of my favorite wines. Thank you to Roberta Bertero, wife of Angelo Bertero Jr., and Andrea Bertero-Noriega, daughter of Angelo Bertero Jr., for providing the photographs and stories from the Bertero Winery days.

Thank you to Dhruv Khanna, owner of Kirigin Cellars, for providing photographs and stories of Kirigin Cellars and the advance wine tasting of some special new wine releases. Thank you to Larry Bonesio, son of Victor Bonesio, for emailing stories from his childhood when he lived with his grandparents, the founders of the original Bonesio Winery. A special big thank-you to Joanne Hall, daughter of Louis Sr. and Merle Bonesio, and her husband, George Hall, for their efforts to locate their precious Bonesio family photographs.

Many thanks to Larry Kwong, owner of the Printing Spot in Gilroy, California, for coming to the rescue when I needed help scanning some of the more challenging photographs. This shop is a combination of state-of-the-art expertise and old-school customer service. Larry's work is so respected and he is so well liked that other shops, when faced with a request that they cannot fulfill, send customers over his way—knowing Larry can make it happen.

Thomas Kruse of Thomas Kruse Winery deserves a very special thank-you for generously writing the foreword for this book. Not only is Tom a talented winemaker and senior leader of our local wine industry since the early 1970s, he is also a masterful storyteller and gifted writer. Tom's friendship and endorsement of my book mean the world to me.

I also want to thank my father, Peter Anzellotti, who at age 90 still enjoys a glass of cabernet sauvignon each evening with his dinner. Always encouraging me to follow my dreams, he is an inspiration to me as one of the members of the Greatest Generation who proudly served his country in World War II. My father fondly recalls being a youngster and making zinfandel wine with his father, an Italian immigrant, in their New York City home's basement. The wine they made came from grapes grown in California, likely from the Santa Clara Valley.

And speaking of family, I want to thank Ralph, Linda, Anne, Craig, Kyle, Quinn, Gina, and Kora, for their loving support and encouragement, and my late mother, Anne, and late brother, Peter, who would have also enjoyed reading about the history of our wineries.

Also, special thanks to my close friends we call the Fun Bunch: Barbara and Ben Leone, Barbara and Steve Portera, and Daniene and Bill Marciano. Through their prodding, I started to write a wine column about our local wineries. It was from my writing of the wine column that Arcadia Publishing learned about me and asked me to write this book.

This leads me to thank Ginny Rasmussen, the acquisitions editor for Arcadia Publishing, who first contacted me about this book and whose patience, encouragement, and expertise led me to the successful conclusion of this book.

INTRODUCTION

The wineries of Santa Clara Valley have a rich history, dating back to the 1700s. First came the Spaniards, then the Frenchmen, and finally the Italians. The secret was out, the mild climate here in Santa Clara Valley was ideal, not only for growing vines, but also for living comfortably. The Spanish padres founded Mission Santa Clara in 1777, and seeing snarls of native grapevines climbing the trees along the creeks and valley, they knew that their grape cuttings would thrive here. Although the quality of the wine varied, much of it was crude and mostly used for religious purposes.

In the mid-1800s, the French started to arrive, first lured to the Sierra Mountains by the Gold Rush and then settling in the San Jose area for all the good land available. The French greatly improved the quality of wines by planting the right varietals and employing years of established techniques to improve vineyard health and grape quality.

By 1880, the Italians came in droves, bringing their fruit-growing skills and hard work ethic to share in the bounty of the Santa Clara Valley. The Italians did most of the pruning, with centuries of best practices behind them.

Thousands of acres were planted in grapevines. Most of the young wine was sold to the growing population and restaurants in San Francisco—oftentimes finished and blended there for further sale and shipped off to other parts of the country.

The booming wine industry almost ground to a halt in the early 1900s. First, phylloxera appeared—a tiny, sap-sucking aphid that threatened to wipe out most of the vineyards. As winemakers struggled to stop the devastation of this pest, in 1906, the San Francisco earthquake hit. The resulting fires destroyed 15 million gallons of wine and several major wine cellars. With little time to recuperate from phylloxera and the earthquake, Prohibition started in 1920, criminalizing the manufacture and sale of wine. And to cap it all off, the Great Depression began in 1929. People could hardly afford bread, let along wine.

Many of our wineries tore out their remaining vineyards and sought other ways to make a living. However, more than a few of our valley winemakers stayed the course, keeping their vineyards alive by either selling their wine to a church (which was legal) or secretly selling their wines to people of all walks of life, including the police and other government officials. Trapdoors, secret cellars, and get-away cars were the name of the game.

With the end of Prohibition in 1933, the wineries slowly made a comeback. For the next 30 years or so, most wine was called jug wine. People would bring their own jugs to the wineries and ask for a fill up. They had two choices: red or white. Wines were usually a blend of several kinds of grapes, and the varietals or vintage years were not specified.

In the mid-1900s, the Santa Clara Valley was a profusion of orchards and vineyards from one end to the other. Our wine region famously became called the Valley of Heart's Delight.

When the Judgment of Paris occurred in 1976, the California wine industry exploded. At a blind tasting of French and American wines, an all-French panel of wine experts awarded the top honors to several California wines. Mayhem ensued when the French wine judges learned that

the California wines had won. Several of the judges stormed out in protest, bitterly denouncing the contest.

The mystique of Old World, French wines gave way to the New World of California wines as the finest in the world. In fact, California produces such excellent wine that 90 percent of all American wine is produced in California, ranking the Golden State just behind France, Italy, and Spain as the top-producing wine grower in the world.

To this day, the Santa Clara Valley remains the first premier winegrowing region in the state and is home to many world-class, award-winning wineries. Thanks to nearby Silicon Valley, our vineyards employ state-of-the-art technology measuring soil, moisture, wind, and temperature conditions. Our wines are now labeled to specify varietals and vintage year.

Our winemakers and owners are farmers at heart. They talk constantly about how the very quality of their wine starts in the vineyard. Although Mother Nature is a strong influence on the outcome of the grape quality, each winemaker has his or her own technique and skill to bring the best tasting wine to consumers' glasses. Winemaking is part science, part art form, and, some would say, part magic.

Despite the quality wines being produced here in the South Valley, visitors and even some residents still express surprise to learn that there are so many wineries between Morgan Hill and Gilroy. To their delight, they are finding out that each winery offers its own ambience, decor, and accommodations, a different feel for just about any mood or personality, ranging from Old World elegance to rustic, contemporary, or even whimsical. Some wineries offer sweeping views, bocce ball courts, picnic tables, and deli items. Year-round events include live music concerts, cooking demonstrations, holiday fairs, and wine-stomping contests. But for all their differences, all are far from pretentious. They are still family owned and operated. Some winemakers even have day jobs, juggling two careers at once. It is common to find the owners and winemakers on the premises, if not in the tasting rooms, happy to pour a sip and answer any questions.

This book highlights the stories and photographs of eight of our Santa Clara Valley wineries whose histories date back to the 1800s. A good number of these wineries have their roots in Italy, with names like Guglielmo, Fortino, Colombano, Sampognaro, Bonesio, Bertero, Vanni, and Pedrizzetti. But just as many have their roots in other countries. What they all have in common is an incredible work ethic, a love of the land, and a devotion to their families.

This book is a tribute to all the hardworking ancestors who brought centuries of experience from their homelands and paved the way for all the existing wineries of Santa Clara Valley. May we honor them by carrying out the very best that they have taught us.

This book is not intended to be a comprehensive collection of all the wineries that ever existed. Instead, the eight wineries in this book are the ones that are still in operation and, more importantly, who still have people alive who can recount the stories and are willing to share their photographs. Some of these wineries changed hands over the years, necessitating several families to share their chapter about the same winery.

One

GUGLIELMO WINERY

As one of northern California's wine pioneers, the Guglielmo Winery holds the distinction of being the oldest continuously operated family winery in Santa Clara Valley. Guglielmo wines are so highly regarded that on May 8, 2014, they were the only wines served at Pres. Barack Obama's fundraising dinner at the Fairmont Hotel in San Jose, California.

Born in 1883 in Gravere, Italy, Emilio Guglielmo came to America in 1909. Soon after, he sent for his village sweetheart, Emilia, and they were married the very next year. For the next 15 years, they worked and saved, with Emilio toiling away at a tannery and Emilia at a French laundry in San Francisco. By 1925, with their saved earnings, they purchased a home on 15 acres in Morgan Hill of Santa Clara Valley. It was at this time that Emilio Guglielmo Winery was founded.

Emilio and Emilia's son George W., along with his wife, Madeline, joined the family business in 1945. Customers would bring their empty jugs for recycling to the sales room, and they could taste a glass of wine before purchasing a case or two of either burgundy (a red blend) or sauterne (a white blend).

By the 1980s, the winery was passed on to the third generation, George W. and Madeline's three sons: George E., Gary, and Gene, who carry on the traditions of hard work and fine winemaking. They are well known for loaning equipment and sharing their expertise with new wineries just getting started. Their charitable generosity with their family, friends, and community is unparalleled, making them respected and lovable members of the community.

Today, the house where Emilio and Emilia began and in which the current generation remembers growing up is still standing and has now become offices for the winery. The original secret cellar is still used to store up to 20,000 gallons of wine. The winery is rich in the charm and tradition of Italy. Beyond iron gates and a cobblestone courtyard lie a tasting room and a covered lawn area popular for weddings, concerts, and corporate meetings.

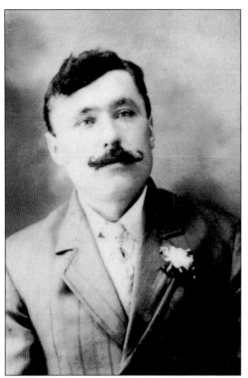

In 1883, Emilio Guglielmo, the patriarch of the Guglielmo family, was born in Gravere, near the French border of Italy's Piemonte region. Emilio was fluent in both French and Italian. When Emilio was 26, he traveled to America, only wanting to stay long enough to make a little money. He arrived at Ellis Island on September 19, 1909. Working his way west, Emilio arrived in San Francisco in June 1910. Impressed with the beauty and opportunities of the Santa Clara Valley, Emilio decided to stay and make it his home. (Courtesy of the Guglielmo family.)

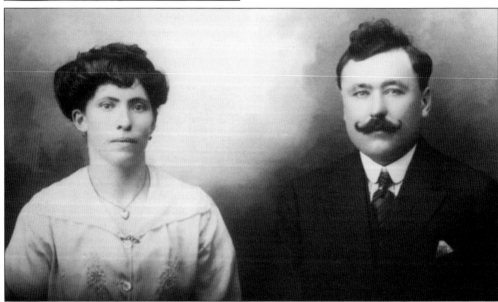

Emilio soon sent for his village sweetheart, Emilia Guglielmo, and they were married in November 1910. For the next 15 years, they worked and saved; Emilio toiled away at a tannery, and Emilia worked in a French laundry. By 1925, with their saved earnings, they purchased 15 acres in Morgan Hill of Santa Clara Valley, where Emilio could continue his family's tradition of winemaking. It was at this time that the Emilio Guglielmo Winery was founded. This is Emilia and Emilio Guglielmo's wedding photograph, taken in San Francisco in 1910. It was pure coincidence that they had the same name. (Courtesy of the Guglielmo family.)

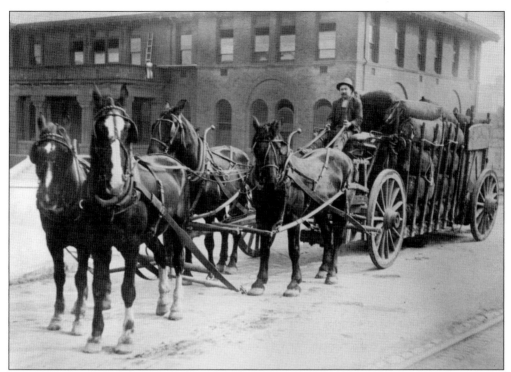

This early-1900s photograph shows Emilio driving a team of horses to the tannery in "Butchertown," the nickname for the 81 acres of waterlogged tidelands in southeastern San Francisco used for slaughtering animals. The city's butchers had been forced to move here after an ordinance forbade the slaughtering of animals and the smells and sounds that went with it in the town's center. Related industries quickly followed: tanneries, fertilizer plants, wool pulleries, and tallow works. (Courtesy of the Guglielmo family.)

In 1923, Emilio and Emilia's son was born on George Washington's birthday, and the new immigrants proudly named him after the first president. With the desire to assimilate into the American culture, they spoke only English at home, occasionally speaking Italian when their friends came over. George W. Guglielmo (center) is pictured here at about four years of age. (Courtesy of the Guglielmo family.)

13

A group of immigrants from the Piemonte region of Italy frequently socialized, getting together for dinners and barbeques. Many were winemakers, including Emilio Guglielmo, fourth row, fourth from left, and Camillo Colombano, third row, third from the right. George W. Guglielmo, just a few years old, is sitting on the ground wearing a cap, fourth from the right. (Courtesy of the Guglielmo family.)

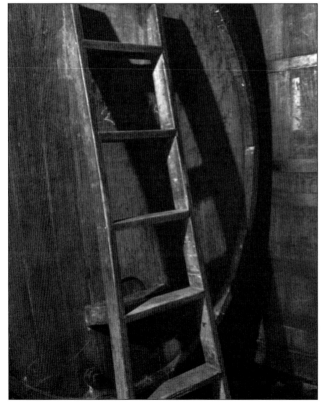

During the Prohibition years, between 1920 and 1933, it was illegal to make or sell alcohol, except in small quantities for home use or for religious purposes. A trapdoor located beneath Emilio's bedroom floor led to a secret cellar, which held several tanks of wine. Emilio supplied his family, churches, and even an elected official or two. Pictured here is the ladder that was used to descend from the bedroom into the cellar. (Courtesy of the Guglielmo family.)

After Prohibition was repealed, the rest of the basement was dug out to make room for additional storage. Storm doors and concrete steps were added to the outside of the cellar, eliminating the need to use the trapdoor and making access to the stored wine easier. This basement area still stores up to 20,000 gallons of wine at any given time. (Courtesy of the Guglielmo family.)

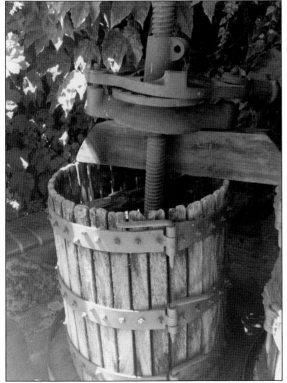

This basket press was made by Bianchi's Machine Shop in San Francisco. This design was typical of those used by small wineries and home winemakers in the early 1900s. The basket press was used to separate the juice from the skins and seeds. Early models such as this one relied on a worker turning the crank by hand to exert the pressure needed to squeeze the juice from the grapes. Later versions of these presses were motorized. (Courtesy of the Guglielmo family.)

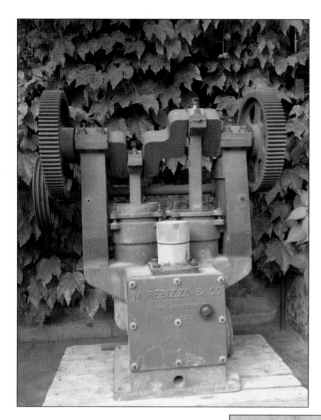

After crushing the grapes, seeds, and skins, the juice (called must) was pumped to the fermentation tanks to begin the winemaking process. Made by M. Rebizzo & Company in San Francisco, this pump is featured in some of the oldest photographs of the Guglielmo family history. Emilio Guglielmo began using it in the 1930s, and it served the family well through the harvest of 2000. Since ferrous metals can impart a metallic taste to wine, this machine is constructed entirely of brass. (Courtesy of the Guglielmo family.)

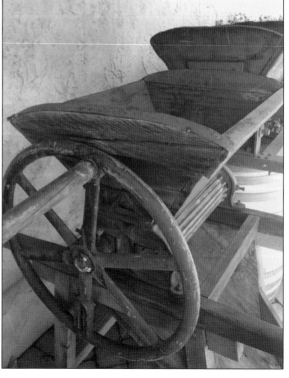

This portable grape crusher was initially used to crush the grapes after harvest. Portable crushers of this design were used around California wineries since the late 1800s. The portability of these crushers enabled early winemakers to move the piece around the winery and crush directly into the fermentation tanks, avoiding pumping. (Courtesy of the Guglielmo family.)

Emilio Guglielmo, pictured here with his good friends from the Belletto family, helps to bring in the 1943 harvest. When Emilio traveled from Italy to America in 1909, he only wanted to earn some money and fully intended to return to his homeland. But Emilio soon realized the beauty and the opportunities here in California. He met other immigrants from France and Italy, and they became a group of lifelong friends. They depended on each other for help on their farms and in their vineyards as there was no other source of farm help at that time. (Courtesy of the Guglielmo family.)

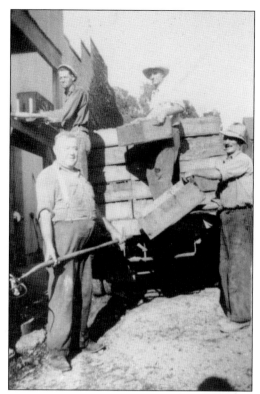

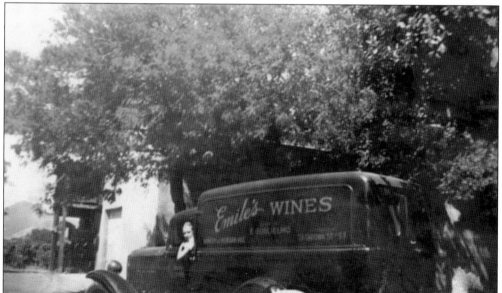

Delivering wine at age 14 in a panel delivery truck, George W. Guglielmo was able to obtain a special driver's license to follow his father, Emilio, from Morgan Hill to San Francisco in 1938. The truck's signage says "Emile's Wines" (Emile is French for Emilio) because it was more fashionable to be French in that era. And since many of his friends and customers were French, they called him Emile. The label was changed and updated to Guglielmo in the 1970s. (Courtesy of the Guglielmo family.)

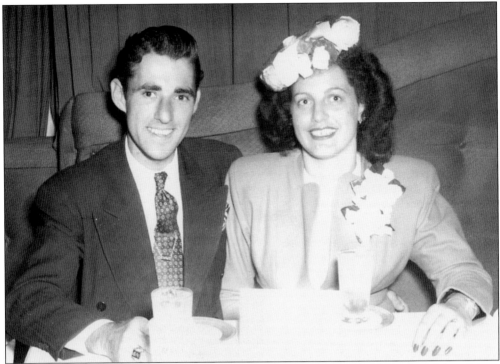

Emilio and Emilia's son George, upon his return from World War II, married Madeline Marie Sordello. This photograph is of George and Madeline on their honeymoon in Hollywood, celebrating at the Brown Derby Restaurant in 1946. After their marriage, George and Madeline moved in with Emilio and Emilia and began working in the winery. Working together, George and Madeline expanded the winery's estate vineyards and distribution channels. George and Madeline had three sons: George Emile (1947), Gene (1949), and Gary (1956). (Courtesy of the Guglielmo family.)

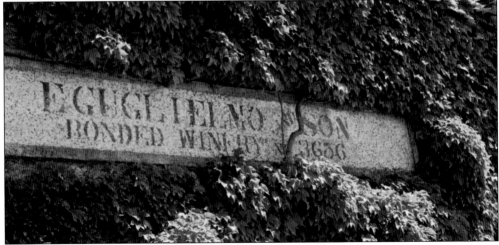

This is the original sign from the 1930s that Emilio made. Around 1945, when George returned from World War II and joined the winery, "Son" was added to the sign. Bonded refers to the coverage that a winery is required to have by the TTB (Alcohol and Tobacco Tax and Trade Bureau) for their excise tax liability due to the federal government. (Courtesy of the Guglielmo family.)

In a coincidence so amazing it was published in *Ripley's Believe It or Not* in 1935, Madeline Sordello and her two brothers were all born on February 8, exactly one year apart to the day, three years in a row. Raymond was born first in 1923, then came Madeline in 1924, and finally Antone "Nene" in 1925. Nene is sitting in front of Raymond and Madeline in this 1930s photograph. When she grew up, Madeline became the family matriarch when she married George W. Guglielmo after he returned home from World War II. (Courtesy of the Guglielmo family.)

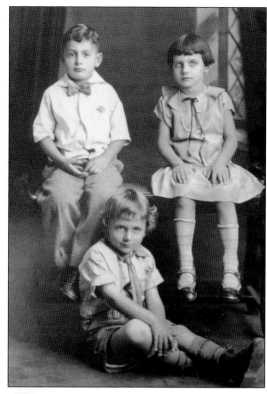

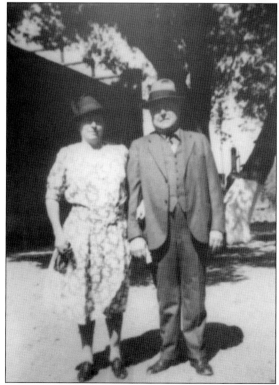

Pictured here are Noni and Nono (Emilia and Emilio) in their front yard after returning from Sunday mass. Hardworking and ambitious, they were regarded as ethical, frugal, and giving people by their friends and family. Noni learned to cook from a French woman named Gross Marie (Fat Marie) and prepared meals with cheese, butter, and polenta made with the rabbits and pigeons they raised. Wine was always experienced with food and not normally consumed by itself. Although Emilio and Emilia were affectionate toward their children and grandchildren, they could also be stern about enforcing good behavior and principles of right and wrong. (Courtesy of the Guglielmo family.)

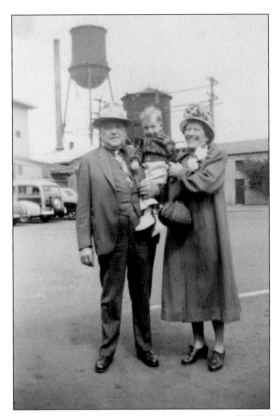

In this photograph, Emilio and Emilia are leaving for a visit to Italy in 1949. They are holding their grandson George E. They took a train from San Francisco to New York and then boarded a boat that took them the rest of the way to Italy. Once they arrived, they visited Emilio's two sisters. To this day, the Guglielmo brothers stay in touch with their Italian cousins and occasionally visit each other. (Courtesy of the Guglielmo family.)

In 1962, the three brothers had their photograph taken in front of a wooden backdrop during a family outing at the Santa Cruz Beach Boardwalk. Pictured are, from left to right, Gary, George E., and Gene. Family outings were special occasions, and the three boys were dressed in collared shirts, shoes, and socks. They especially loved to ride the Big Dipper, a popular roller coaster built in 1924 and still in operation. (Courtesy of the Guglielmo family.)

George and Gene Guglielmo are shown here standing near barrels of aging wine, and Gene is holding a 1969 bottle of Mt. Madonna Petite Sirah. As leaders in their industry, they were one of the first wineries to begin the trend of identifying the grape varietal and placing the vintage date on the bottle. Prior to this, Guglielmo Winery did not vintage date any wine. (Courtesy of the Guglielmo family.)

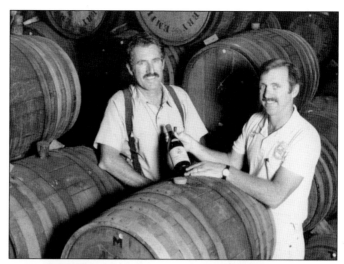

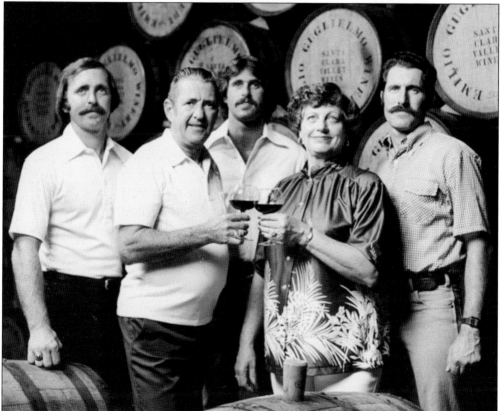

The Guglielmo family poses for a photograph in 1982; from left to right are Gene, Gary, and George, with their parents, George W. and Madeline, toasting the camera. Everything in life centered on family. Growing up, the three sons felt blessed to be raised by and to work alongside both parents and grandparents. George W. did all the winemaking and vineyard management while Madeline took care of the tasting room and kept the books. The boys were their field and bottling help. The family gathered together every evening for a home-cooked dinner and to share their experiences from the day. (Courtesy of the Guglielmo family.)

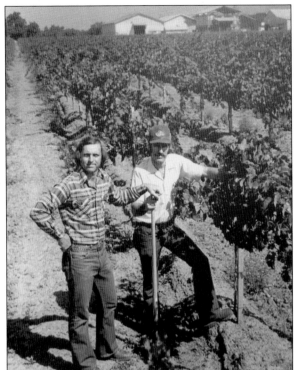

In 1978, brothers Gene (left) and George E. (right) work on the Petite Sirah vines at the winery. A decade earlier, George E., the oldest of George W.'s sons, graduated from Fresno State University with a degree in viticulture and enology. At that time, there were only 175 wineries in the state of California—now there are over 5,000. With his newfound knowledge, George E. convinced his father that instead of producing blended wines, they should be bottling single varietals. In addition to George E.'s contributions to the business, Gene, George W.'s second son, was key in promoting the resurgence of the Santa Clara Valley wine region in 1989. Gene filed a petition to designate a distinct American Viticultural Area (AVA) for the valley, and on March 28, 1989, the Santa Clara Valley AVA was finally declared. (Courtesy of the Guglielmo family.)

This is a scenic view of the Guglielmo vineyard against the rolling hills of the Santa Clara Valley. There are 50 acres of planted vines on the winery property in Morgan Hill, including Zinfandel, Merlot, Petite Sirah, Grignolino, Cabernet Sauvignon, Sagrantino, and Carignane varietals. (Courtesy of the Guglielmo family.)

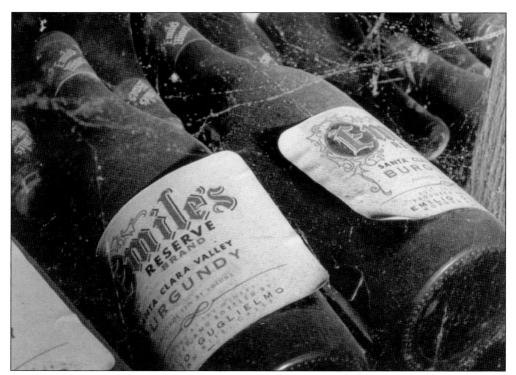

The library of family reserves, including the original Emile's Wines label, is covered with dust and cobwebs. Various red grapes were blended together and labeled as burgundy, and white grapes were blended together and labeled as sauterne. In the 1970s, the Guglielmo label was created for the varietal wines they started to produce. Additionally, there is a Tre label for their mid-range wines. Tre (three in Italian) is symbolic of the three generations and three sons now running the business. (Courtesy of the Guglielmo family.)

The courtyard has been transformed into a charming, old-world piazza reminiscent of the Italian towns of their ancestors. The winery and the Villa Emile Conference and Event Center hosts weddings, festivals, celebrations, and corporate events. (Courtesy of the Guglielmo family.)

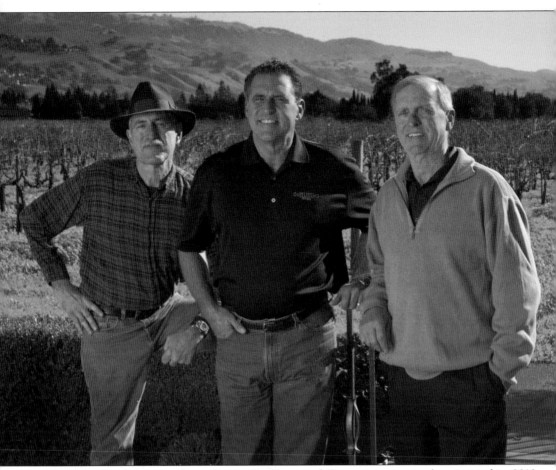

The three Guglielmo brothers, George E., Gary, and Gene, pose out in the vineyard in 2010. Today, the third generation, George E. (winemaker and president), Gene (director of sales), and Gary (general manager), retains the family tradition of producing award-winning premium varietal wine from their Santa Clara Valley estate vineyards, as well as wines from other premium winegrowing regions within California. (Courtesy of the Guglielmo family.)

Two

ROSS VINEYARDS AND WINERY

Judy and Jerry Ross are the proud owners of 55 acres of the old original 300-acre Coffe Ranch in Morgan Hill, with its sweeping views of the surrounding hills, Paradise Valley, and Chesbro Reservoir. Joseph and Josephine Coffe, French immigrants, purchased the ranch in the early 1900s. Their grandson Alphonse J. "Buddy" Pauchon was the last descendant of the Coffe family and lived out his life on this ranch.

As a close neighbor, over time Buddy became a beloved member of the Ross family. Before he passed away in 1999 at the age of 87, he convinced the Rosses to plant a vineyard: "Good grapes have always been grown here on this land—why don't you plant some?" They took Buddy's advice and planted two acres with a dozen different varietals, including Cabernet, Tempranillo, Malbec, Sangiovese, Barbera, Merlot, Petite Sirah, Zinfandel, Pinot Noir, and Rhone varietals such as Grenache, Syrah, and Mourvedre.

The Rosses' early harvests started out producing 300 cases per year, more than enough to drink or give away to friends. Before long, the barrel room reached over 1,000 cases, and they were running out of storage. In order to make room for new vintages, it was only logical for Judy and Jerry to start selling their wine to the public. They named their new business Ross Vineyards and Winery.

Judy and Jerry lovingly compiled conversations with Buddy and sorted through the old black-and-white photographs of his family, not only to preserve the rich treasure of history that resided within Buddy, but also to honor the friendship that they enjoyed with him.

Just as surely as the Rosses have recorded the Coffes' existence so many years ago, they, too, will leave their legacy on the land. Judy and Jerry have lived on this ranch for more than 40 years. Jerry worked six days a week at a gas station he owned in San Jose, California, while Judy stayed home to raise their three sons. Now retired, but still young at heart, they are enjoying their second career in winemaking. Their grandchildren are their pride and joy, and their adult grandson Jim is the tasting room manager.

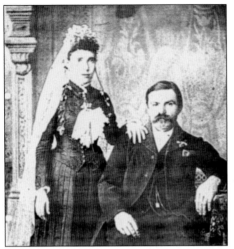

Joseph Coffe, born in Nef, France, first came to America when he was 24 years old, in 1870. He started a bakery, and in four years he had saved enough money to open a winery business in San Jose, which he named the Wine Depot. He married 18-year-old Josephine Jaussaud, even though he thought she was a little *alleaus* (goofy looking) due to her weak eye, which crossed in slightly. Joseph Jr. quickly adjusted to this small deficit, married her, and took her home to San Jose. This remained a fond story through family generations. (Courtesy of the Ross family.)

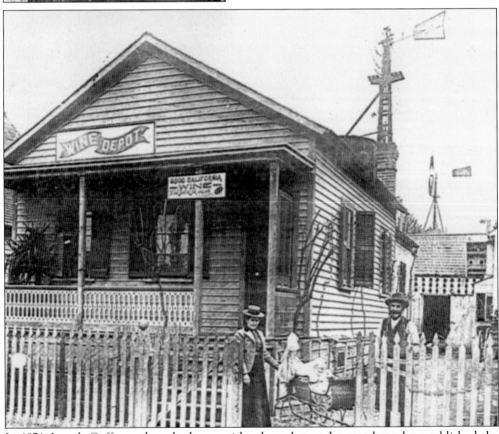

In 1874, Joseph Coffe purchased a home with a large lot, and a year later, he established the Wine Depot in downtown San Jose, California. The winery was located half a block south of the modern iconic restaurant Henry's Hi-Life, and it was one of the earliest commercial wineries in San Jose. From 1875 to 1925, Coffe vinted fine French-style wines from grapes grown by his brother Eli and his daughter Josie Coffe Pauchon on their ranch in the Uvas Valley of Morgan Hill. Pictured here around 1884 are Joseph and Josephine Coffe and their daughter Josie in front of their wine shop. (Courtesy of the Ross family.)

The Coffees' daughter Josie met Alphonse Pauchon in 1906, when he was a dapper-looking waiter at Lamolle Grill in downtown San Jose. Even though Alphonse would stop by the Wine Depot every night to fill his jug full of wine, Josephine must not have realized that Alphonse was a hopeless alcoholic, and she married him in 1908. Alphonse was 29, and Josephine was 24. (Courtesy of the Ross family.)

Here is a family photograph of Joseph Coffe, standing, with his wife, Josephine, sitting before him. Also standing is their daughter Josie with her two children before her: Lorraine (seven) and Alphonse Jr. (four). Everyone called little Alphonse Jr. "Buddy" to avoid any confusion with his father, Alphonse Pauchon Sr., an alcoholic and ne'er-do-well, rarely seen in any family photographs. This photograph was taken in 1916. (Courtesy of the Ross family.)

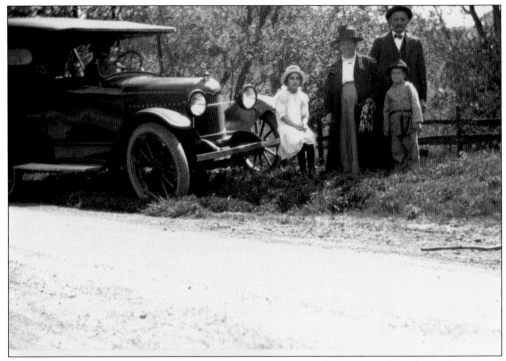

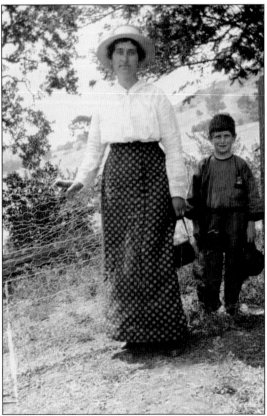

Around 1915, Joseph and Josephine Coffe purchased a 300-acre ranch in the Paradise Valley region of Morgan Hill, along Llagas Creek, which is now Chesbro Reservoir. On this ranch, Joseph Coffe planted 40 acres of grapes for winemaking at his successful business, the Wine Depot, in San Jose. Here are Joseph and Josephine with their grandchildren Lorraine and Buddy, who came to visit them on their ranch. (Courtesy of the Ross family.)

Josie moved her family to her parents' ranch in 1918 in an attempt to get her husband away from his drunken friends in San Jose. At the very least, the ranch was a place where they could grow their own grapes and support Alphonse Sr.'s thirst for alcohol. In this photograph, Josie was 34, and Buddy was six. (Courtesy of the Ross family.)

Alphonse Sr. never drove a car. Here he is, riding with Buddy and Lorraine. Josie must have taken this photograph. It appears that the vehicle is an Allen Touring Car, made in Columbus, Ohio, between 1917 and 1920. (Courtesy of the Ross family.)

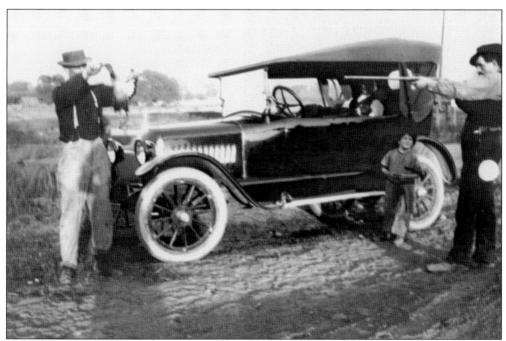

Alphonse Sr. reenacts shooting a bird with his double-barrel shotgun. His brother-in-law, Louie Coffe, displays the trophy by its wings. His son Buddy watches in rapt attention while Joseph Coffe looks on from the backseat of their car. The family cooked and ate most any kind of bird. (Courtesy of the Ross Family.)

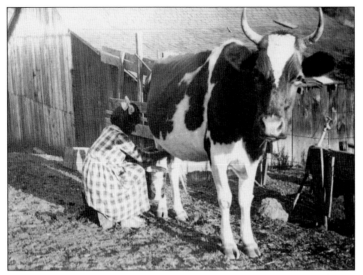

In 1919, Lorraine milks a docile Holstein cow while sitting on a prune box. Most people are surprised to learn that both female and male cows have horns. Lorraine was likely getting ready for school and needed milk for breakfast. She walked the three miles up and back to Machado Elementary School, which still operates in Morgan Hill to this day. (Courtesy of the Ross family.)

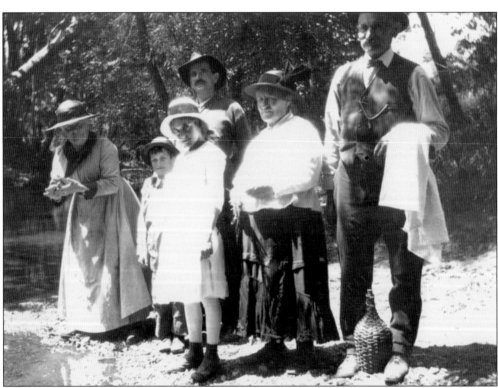

In 1919, this photograph was taken along Llagas Creek on the Coffe Ranch. From left to right are an unidentified guest, Buddy, Lorraine, Louis "Uncle Louie" (in back), Josephine, and Joseph. The family often picnicked alongside the creek, which ran through their property. Note the wicker-wrapped wine bottle between Joseph's feet; wicker was commonly used to protect the fragile glass during transport. (Courtesy of the Ross family.)

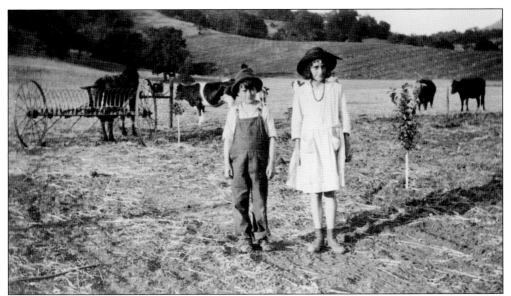

Buddy and his sister Lorraine are standing on their ranch among the livestock and rolling hills. Behind them, a horse is pulling a hay rake. This photograph was taken when they were still quite young, around 1920.

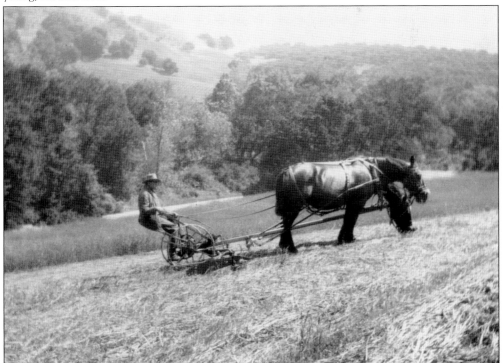

Louie Coffe, Joseph Coffe's son, is seen here in 1922 on a wheeled riding plow. At one point in Louie's life, he herded sheep from Gilroy to Los Banos for Henry Miller, one of the largest private landowners in the United States. Although Louis detested ranch work, he loved horses and was eventually placed in charge of looking after the Coffes' ranch horses. (Courtesy of the Ross family.)

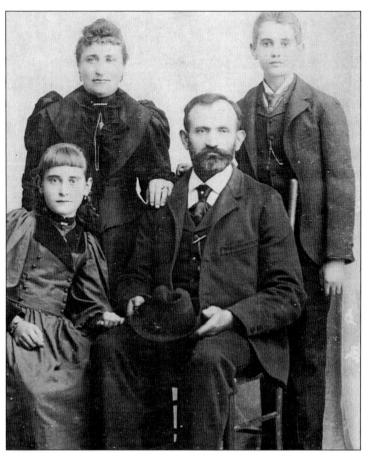

This is a rare photograph of the entire Pauchon family, taken in 1924. Joseph Coffe's daughter Josie is standing on the left next to her son Buddy. Josie's daughter Lorraine is in front next to Alphonse Pauchon Sr. (Courtesy of the Ross family.)

When this photograph was taken in 1924, Joseph Coffe was 78 years old. He is shown with, from left to right, Lorraine, Josephine, and Buddy. Within a year's time, Joseph passed away at the age of 79, but his descendants resided on the beautiful Coffe Ranch until 1999. (Courtesy of the Ross family.)

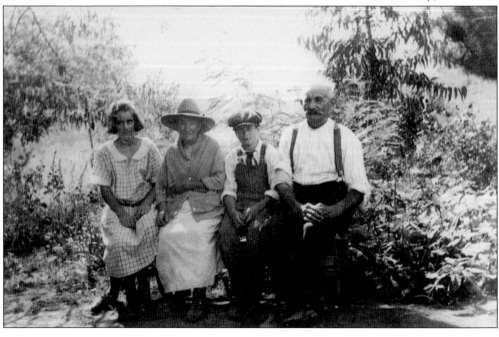

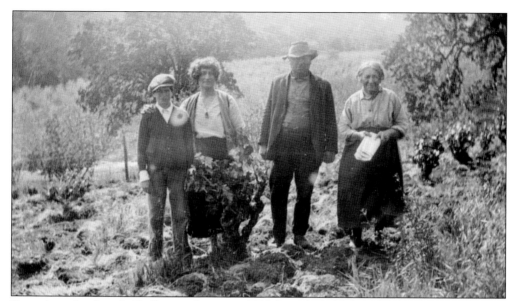

Sometime after Joseph Coffe passed away in 1925, Josie (second from left) took over the job of running the ranch. She is pictured here out surveying the vineyard with her son Buddy and Jim Fourcade, the ranch hand, along with Josie's mother, Josephine. (Courtesy of the Ross family.)

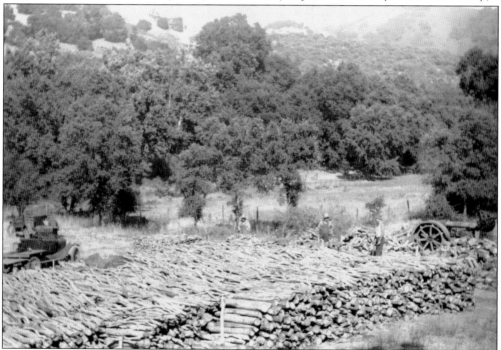

In this 1925 photograph, workers on the ranch can be seen harvesting oak firewood. At this time, the Coffe Ranch included 300 acres, filled with oak trees. Along with his successful business, the Wine Depot, Joseph Coffe also made a living out of selling firewood for the first 10 years that he lived on the ranch, waiting for the fruit orchards to start producing. The workers used handsaws to fell the trees and then a saw mounted on a tractor to cut the wood into pieces. Stacked and delivered oak firewood sold for $10 per cord. (Courtesy of the Ross family.)

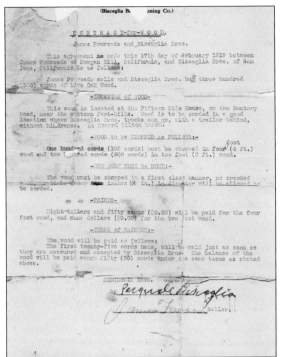

This contract, dated February 17, 1919, was between ranch foreman James "Jim" Fourcade and the Bisceglia brothers. The Bisceglia brothers purchased 300 cords of live oak wood, with 100 of the cords chopped in four-foot pieces and the remaining 200 cords chopped in two-foot pieces. The four-foot pieces were cheapest, at $8.50 a cord, and the two-foot cords cost $9 apiece. (Courtesy of the Ross family.)

This photograph of Joseph Coffe's granddaughter Lorraine was taken in 1929, when she was 20 years old, at the edge of their 300 acres along Llagas Creek. Little did she realize that within 25 years, the County of Santa Clara would snatch up 200 of these acres via eminent domain in order to build a water-retention dam. All of the land where she is standing is now under the waters of Chesbro Lake and Reservoir, which was constructed in 1955. (Courtesy of the Ross family.)

Lorraine Coffe is shown here in 1929 with draft horses and Jim Fourcade, their ranch hand, in the background. Although Lorraine was never considered a classic beauty, she lost what looks she had sometime during her early 20s. According to her brother Buddy, Lorraine got on a health kick and started to take handfuls of vitamins after articles about their benefits appeared in magazines. Thereafter, Lorraine took on a masculine appearance. (Courtesy of the Ross family.)

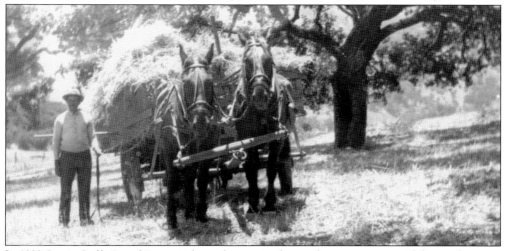

In 1929, Louie Coffe, Joseph's son, is shown harvesting hay with two massive ranch horses, between 16 and 17 hands and weighing up to 2,000 pounds each, sturdy enough to pull heavy wagons and plow acres of soil. All of the land was tilled with teams of these draft horses. One day, Louie took the horses and wagons to downtown San Jose, a day trip there and a day trip back, to pick up a load of bricks. On the return home, the wagon was so heavily laden with the bricks that the wheels cut grooves in the asphalt road, and Louie was ticketed by the sheriff. (Courtesy of the Ross family.)

Pictured here is Jim Fourcade, the family's ranch hand for 40 years, from 1929 to 1969. During Prohibition (1920–1933), Jim built a moonshine still, hidden inside one of the ranch homes. The still produced so much steam that all of the plaster fell off the walls of the house. An established bootlegger, Jim once outran the sheriff with a car full of booze and hid it all under a bridge before the sheriff caught up to him. Without finding any of the liquid cargo, the sheriff let him go. (Courtesy of the Ross family.)

In 1930, the Coffe Ranch maintained 40 acres of grapes and 40 acres of plums. This photograph shows how the grapevines were planted between the rows of plum trees as a matter of convenience; plums are harvested and dried into prunes in the summer, while grapes are harvested in the fall. In the early 1930s, the plum and apricot trees finally came into production. But the country was now into the Great Depression, and prices for prunes and apricots remained at rock bottom (2¢ per pound). It was hardly worth the effort to pick the crop. Since Prohibition was still in effect, prices for grapes were not much better. Life on the ranch was not a financial dream come true. (Courtesy of the Ross family.)

During Prohibition, some bootleggers made whiskey and gin from legal but poisonous substitutes. Alphonse Sr. unwittingly drank some tainted booze, lost sight in one eye, and had to have two-thirds of his stomach surgically removed. A swindler convinced Alphonse, during a drunken stupor, to sign over the deed to the house and all the ranch property. Josephine went to court, had Alphonse declared incompetent, and regained her rightful property. Alphonse was admitted to Agnews State Mental Hospital, a facility for the mentally ill, where he died six months later at the age of 50. (Courtesy of the Ross family.)

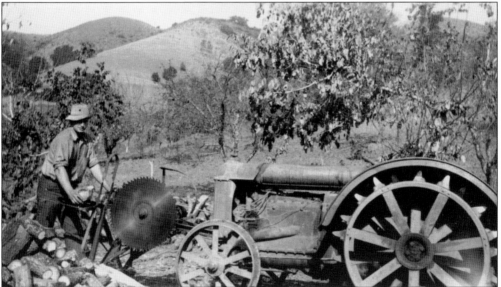

Although Buddy stuttered and was shy, he was considered a genius, having easily graduated from high school when he was only 16 years old. He enrolled in State Teachers College at San Jose (the present-day San Jose State University). The very next year, the Great Depression struck, and Buddy's father, Alphonse Sr., passed away. Josie, his mother, needed him back at the ranch, and he never finished his first year of college. One of Buddy's many jobs on the ranch was to saw logs to sell as firewood. (Courtesy of the Ross family.)

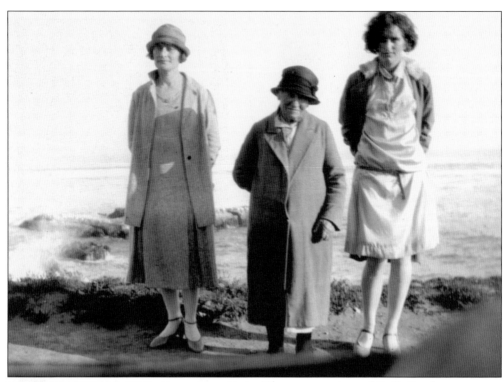

Three generations of Coffe-Pauchon women enjoy a rare holiday together at the coast. Josephine Coffe (center) with her daughter Josie Coffe-Pauchon (left) and granddaughter Lorraine Pauchon (right). Lorraine passed away in 1963 at the age of 53. Shortly before Lorraine died, she wrote a poignant letter to her best friend, who owned the Granada Theater in Morgan Hill, saying that she was dying of ovarian cancer. She had been ill for some time with a fever and pain but was afraid to go to the doctor. (Courtesy of the Ross family.)

Josie poses on the steps of their ranch home in 1942, when she was 57. For 27 years, Josie ran the ranch after her father passed. In 1945, at 60, Josie fell ill with what she thought was influenza, but it was later discovered to be a pulmonary embolism. Exactly one year later to the day, Josie was afflicted by another pulmonary embolism, and this time she did not survive. Josephine died with Alphonse Jr., Lorraine, and Jim Fourcade at her bedside. The great matriarch was gone, and the ranch would never be the same without her. (Courtesy of the Ross family.)

The family was so poor that Josephine could not afford car insurance and forbade Alphonse Jr. to drive their one car. On her deathbed, Josephine finally relented and said, "Take the car to town—go find yourself a good girl and settle down." Buddy was still good looking at 34, but he preferred to stay a bachelor and never did marry. (Courtesy of the Ross family.)

After Josie, the family matriarch, died in 1946, Buddy, Lorraine, and Jim Fourcade continued their meager life on the ranch for the next several years. Nine years later, in 1954, the entire valley floor of the ranch was appropriated for the construction of Chesbro Dam and Reservoir. The county forced the Coffes to sell 200 acres of their 300-acre ranch, which resulted in the loss of all of their prune and apricot orchards and most of the vineyards. Only a small percentage of the vineyards would be left on the northern foothills above the waterline of the lake. The Pauchon-Coffe Ranch, as Josephine once knew it, was no more. This would have surely broken her heart. (Courtesy of the Ross family.)

Pictured here is construction of the Chesbro Dam and Reservoir in 1954. The county paid the Coffe-Pauchons $50,000 for the 200 acres, a little less than $450,000 in today's currency. (Courtesy of the Ross family.)

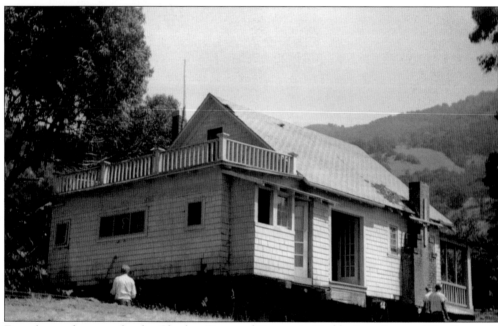

Forced to make room for the Chesbro Dam and Reservoir, Buddy, Lorraine, and Jim Fourcade contracted Kelly Brothers House Moving in 1954 to move all the structures on the property. The Coffe house, shown here, had three bedrooms and a parlor but no kitchen or bathrooms. Chamber pots were kept under the beds. There was no electricity in the home either until after World War II, around 1948. The finished walls inside the house were made from redwood planks covered with canvas and then painted. Three generations of the Coffe family lived and died here from the early 1900s through 1999. Although in disrepair, this home is still standing on the property. (Courtesy of the Ross family.)

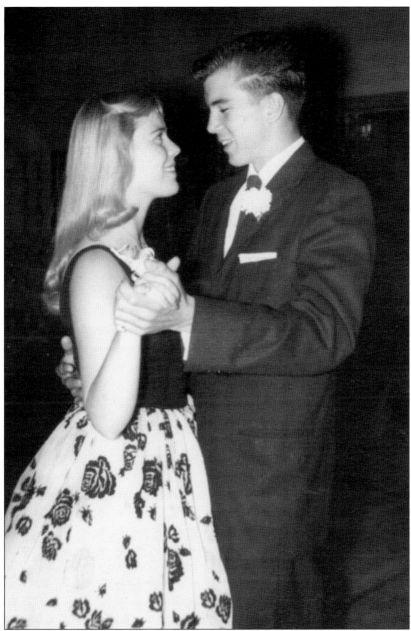

Pictured here in 1959 are high school sweethearts Judy and Jerry Ross, the current owners of the old Coffe-Pauchon Ranch, dancing together at their junior prom at Los Banos High School. Their "going-steady" date was November 22, 1958, which they celebrate every year to this day. After they married, Judy and Jerry purchased land in Morgan Hill in 1972 and built their new home in 1973, becoming close neighbors to Alphonse Pauchon Jr. In short order, Alphonse, the last descendant of the Coffe-Pauchon family, became a beloved member of the Ross family. Over the next several years, Judy and Jerry were able to accumulate three parcels of the old original Coffe Ranch, which comprise the 55 acres they own today. Before Buddy died in 1999, he said, "Good grapes have always been grown on this property—why don't you plant some?" They took Buddy's advice, planted grapevines, and opened their winery in 2012. (Courtesy of the Ross family.)

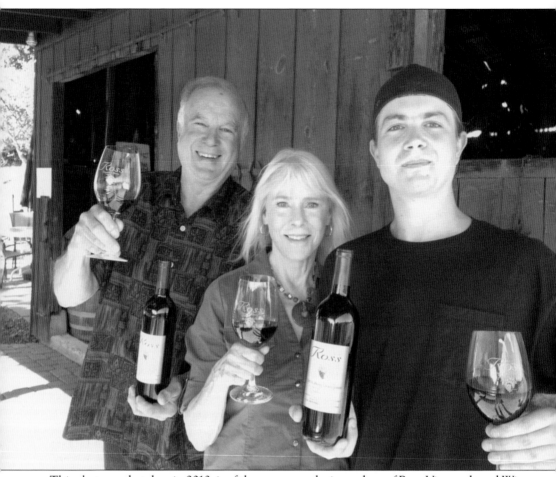

This photograph, taken in 2013, is of the owners and winemakers of Ross Vineyards and Winery. From left to right are Jerry Ross, Judy Ross, and grandson and tasting room manager Jim Ross. A visit to their rustic tasting room is a step back in time, with the original wood planks and square nails from the horse barn built in the 1800s. The covered wagon stays, and horse tack used by the Coffe family hangs from the rafters. Surely Buddy is smiling down from heaven to see their successful wine business, born again from the land that provided grapes and sustained his grandfather's wine shop, the Wine Depot. (Author's collection.)

Three

HECKER PASS WINERY

In 1959, at the age of 21, Mario Fortino immigrated to the United States with his family. The family left a life of hardship behind in the old country of Calabria, Italy, where jobs were scarce and opportunities were slim. Mario came to America full of energy and determination to make a better life. He also brought 150 years of traditional farming methods passed down from his ancestors, which included grape growing and vineyard management.

Mario and his family settled in the county of Santa Clara where fertile soil and ideal growing conditions provided numerous jobs and opportunity. In 1970, Mario and his brother Ernesto purchased a winery on 22 acres of land in Gilroy and called it the Fortino Brothers Winery. Within a couple of years of this venture, the two brothers realized they had different visions for the business and decided to go their separate ways. They divided their property as fairly as possible: Ernesto chose to keep the winery building and a smaller portion of the property, and Mario kept the larger portion of the land without any building.

Speaking very little English and with a limited formal education, Mario established the very successful Hecker Pass Winery in 1972. For over 40 years, Mario, with the help of his family, has produced wines with true Italian character, the only winery in the region to offer Chianti.

Mario's family tradition of winemaking and commitment to excellence continues in the oldest winegrowing region of California, as his son Carlo integrates the time-honored methods of 150 years' experience and the wisdom of three generations of winemakers with the innovative ideas of the future.

In addition to their wine sales, Hecker Pass Winery offers a beautiful venue called La Vigna (the vineyard), managed by Mario's son Carlo. La Vigna is open year-round for weddings, anniversaries, corporate events, birthdays, and any other celebration or event. An indoor banquet room leads to an expansive covered outdoor patio and open dance floor. Views of their 12-acre vineyard and surrounding hills, along with a private bridal room, make La Vigna a spectacular venue for a most memorable event.

One of five children, Mario Fortino was born in the Italian countryside on February 16, 1938. Mario Fortino's parents, Michael and Teresina Fortino, are on the left. Mario's aunt Chiarina and uncle Vincenzo are to the right. This photograph was taken at the Fortinos' home in Calabria, Italy, in 1952. The home was similar to a duplex and shared by these two couples and their children. The land sustained the families with many fruit and olive trees, grapevines, and livestock. They lived without electricity or indoor plumbing. At night, the farm animals were brought inside for safety on the first floor, while the family members slept upstairs. (Courtesy of Mario and Carlo Fortino.)

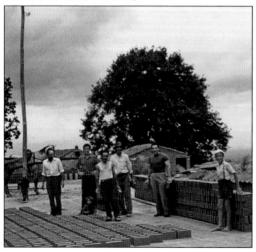

To supplement the living they made from farming their own fruits, vegetables, and livestock, the Fortino family made bricks from their land. Here, the family men are gathered around bricks that are drying in the sun. They made their bricks using the soft-mud process whereby water, clay, and mud were mixed together to make a soft paste. Horses would walk in circles to smash the mixture together. The soft paste was hand pressed into wooden molds and dried in an oven for 26 hours. Sand was used to prevent the clay from sticking to the mold. Semi-dry bricks were removed and taken to a drying area, like the one pictured here. (Courtesy of Mario and Carlo Fortino.)

The whole family gathers inside the brick-making pit around 1950. The poses are natural, without a professional photographer to guide them. Mario Fortino, about 10 years old with a head full of golden curls, is at the very far left with his arm raised. Mario's brother Ernesto is sitting at the very top edge of the pit. The young boys made over 1,000 bricks a day, all by hand. In 1959, Mario Fortino and his family sailed from Calabria, Italy, to New York to follow other relatives and pursue the American dream. (Courtesy of Mario and Carlo Fortino.)

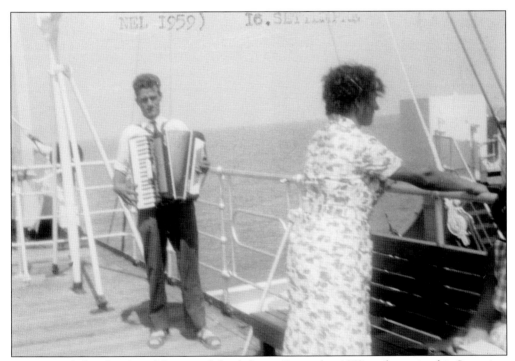

Mario traveled to the United States with his father in September 1959 on the cruise ship *Saturnina*, from the Italian Cruise Line. Italian Cruise Line was a passenger shipping line that provided transatlantic travel between Italy and the United States. The voyage took 13 days from Italy to New York. There were 428 passengers on board during this voyage. Here is Mario playing his accordion to pass the time and entertain fellow travelers. (Courtesy of Mario and Carlo Fortino.)

Mario always loved the natural beauty of the countryside, which reminded him of his hometown of Calabria, Italy. This photograph of Mario was taken by his then girlfriend Frances while out for a drive in the hills of Morgan Hill on May 28, 1961. Frances and Mario wed several years later. (Courtesy of Mario and Carlo Fortino.)

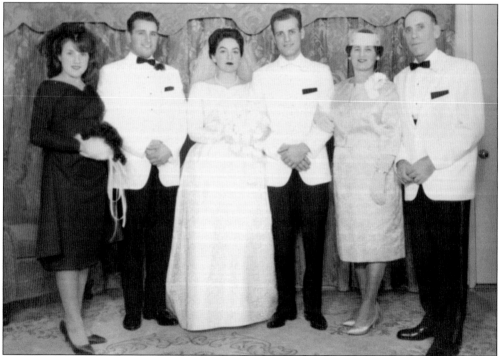

Mario and Frances Fortino are pictured here on their wedding day, December 14, 1964. To the left, Ernesto stands next to their sister Anna, who was the maid of honor. To the right are Mario's parents, Michael and Teresina. Mario and Frances lived happily together for 50 beautiful years before she passed in 2012. Frances was a loving wife and mother and the glue that held the family together. (Courtesy of Mario and Carlo Fortino.)

By December 1968, Mario and Frances had three sons: Mario, Jr. was the oldest, followed by Joseph, and then Carlo in his mother's arms. (Courtesy of Mario and Carlo Fortino.)

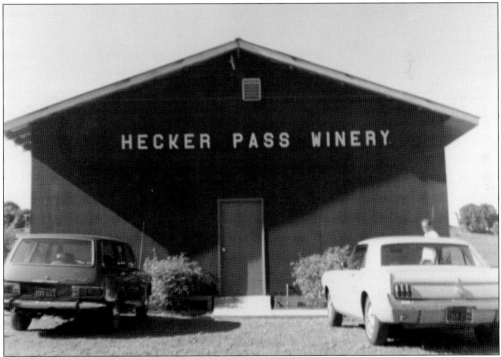

Mario and his brother Ernesto opened a winery called Fortino Brothers in 1970. But each brother soon discovered that they had a separate vision for the business. Ernesto wanted the business to grow, while Mario wanted to keep the business smaller. In 1972, Ernesto renamed the winery Fortino Winery, and Mario opened his own winery called Hecker Pass Winery, named for the highway that connects Gilroy to the coast and passes directly in front of the winery. This photograph shows the original building, which was the winery and wine cellar. The car on the right is a 1964 1/2 Ford Mustang, owned by Mario's sister-in-law Theresa Cortez. (Courtesy of Mario and Carlo Fortino.)

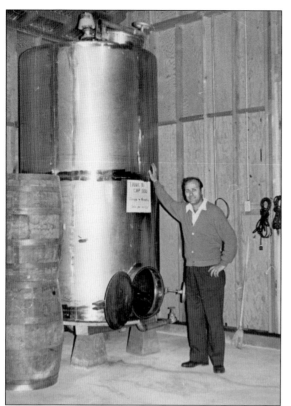

Hecker Pass Winery's first steel tank, with Mario standing beside it, was purchased in 1973 and held 1,100 gallons of wine. This tank was used for aging and racking wine. There was a manhole in front that was used to access the inside of the tank in order to sanitize it. (Courtesy of Mario and Carlo Fortino.)

Hecker Pass Winery is situated on 12 planted acres of vineyards. This photograph taken in the mid-1970s shows the gnarly old vines of a 30-year-old Grenache grapevine. These grapevines were originally planted in 1946 by the Cassa family, which owned the vineyards until 1969. Most of these grapevines are still producing high-quality grapes to this day. Mario, joking around, is engulfed inside the grapevine. (Courtesy of Mario and Carlo Fortino.)

Today's existing vineyard at Hecker Pass Winery is all original, dating back to 1946. The vineyard is managed by traditional methods learned from Mario's Italian ancestors. The vines are all dry-farmed (only rain waters the vines), head-pruned, handpicked, and hand-hoed. Other than a tractor that is used to disc the soil, no other machine is used on the vines. Additionally, the winery does not use any herbicides or pesticides. Only natural, wild yeast is used to ferment the wine, which is all estate grown (grown on the property). (Courtesy of Mario and Carlo Fortino.)

Mario sometimes filters his wines in order to clarify the finished product. Because filtering alters the flavor of wine, Mario only filters his wine when needed. (Courtesy of Mario and Carlo Fortino.)

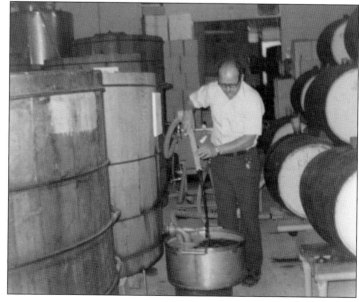

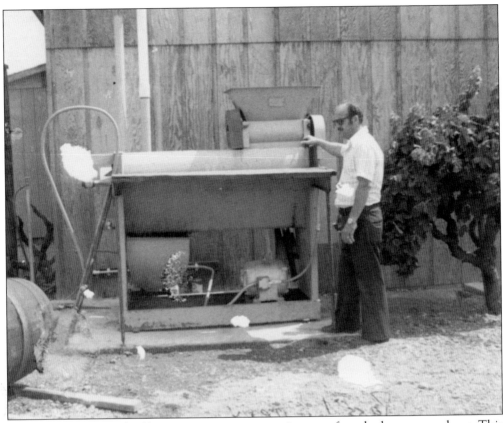

This small, grape crusher/de-stemmer can generate six tons of crushed grapes per hour. This machine gently spins the grapes and removes the stems at the same time. The stems fall to the wayside, and all of the juice goes into a connected tank. Even today, this very same crusher/de-stemmer continues to be used. (Courtesy of Mario and Carlo Fortino.)

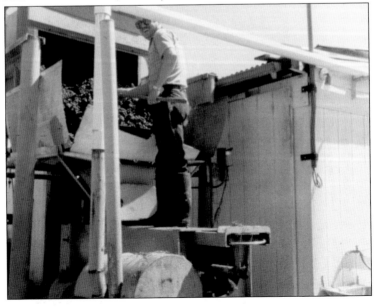

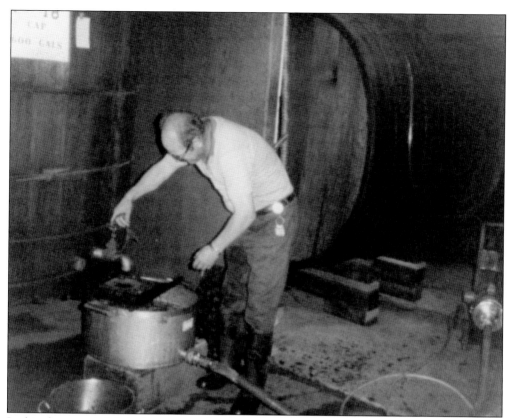

In this photograph, Mario demonstrates how he draws off some free-run wine from the fermentation tank. Free-run wine is juice that is extracted by breaking the skin of the berry during the crushing/de-stemming process. Pressing the grapes extracts even more juice, but at a higher pH level. To make a more balanced wine, many winemakers use a mix of 85 to 90 percent free-run juice and 10 to 15 percent pressed juice. (Courtesy of Mario and Carlo Fortino.)

Mario uses a wine thief, a tube-like accessory similar to a turkey baster, which draws up wine from a barrel into the tube in a small amount. This small amount provides a sample to test how the wine is progressing in every stage of fermentation and aging, testing for pH and acid levels and even taste. (Courtesy of Mario and Carlo Fortino.)

A photograph of the three brothers, Mario Jr., (left), Carlo (middle), and Joseph was taken in the early 1980s. They are gathered around a table of their mother's home-cooked paella dinner. Note the glasses of wine, even though the three boys were in their teens. Wine was a natural part of their evening meals. (Courtesy of Mario and Carlo Fortino.)

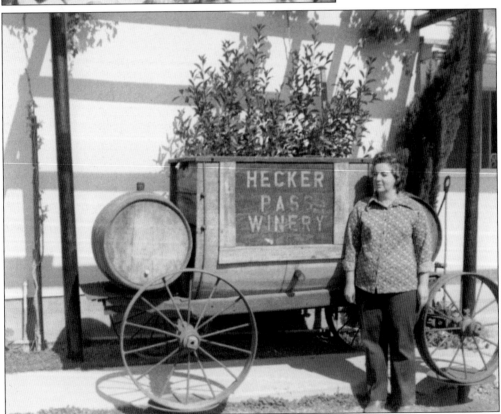

Frances Fortino, sometime during the 1980s, poses in front of a Hecker Pass Winery sign. Although Frances never worked outside of the home, she was a devoted mother, wife, and homemaker. She also worked alongside her husband, Mario, in the winery by taking care of all the record keeping, ordering supplies, and paying taxes. Frances helped Mario build the wine cellar and barrel room; the two did all the heavy lifting together without the help of a forklift. (Courtesy of Mario and Carlo Fortino.)

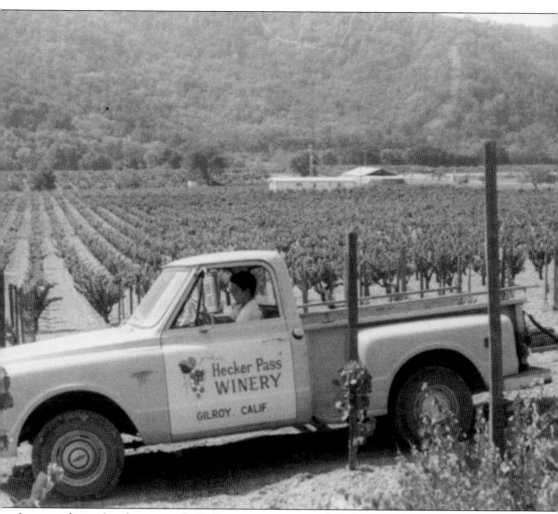

It was traditional and common for Italian parents to name their first son after the father. Here is Mario Jr., the firstborn son of Mario and Frances, when he was just learning to drive, around the age of 14. Mario Jr., along with his other two brothers, helped out in the vineyard by picking and hauling grapes, among any other duties that were needed. (Courtesy of Mario and Carlo Fortino.)

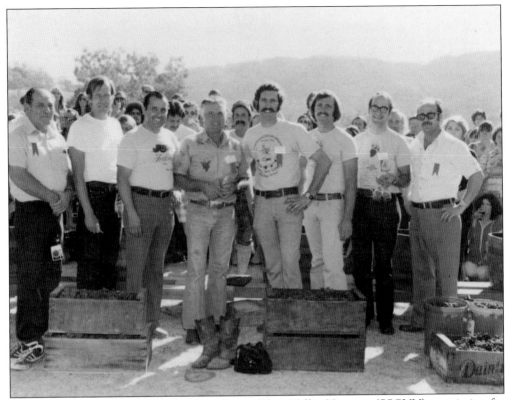

Mario was the president of the Southern Santa Clara Valley Vintners (SSCVV) association for three years in a row during the mid-1970s. The southern wineries broke away from the much larger northern wineries in order to have more control over their own governance. Members of the SSCVV are, from left to right, Angelo Bertero (Bertero Winery), Thomas Kruse (Thomas Kruse Winery), Ernie Fortino (Fortino Winery), Ed Pedrizzetti (Pedrizzetti Winery), George Guglielmo, Gene Guglielmo (Guglielmo Winery), Scott Richert (Richert & Sons Winery), and Mario Fortino (Hecker Pass Winery). They met monthly with suppliers over food and wine, developing relationships and deals that would benefit all parties with volume pricing. The SSCVV lasted until 2003. (Courtesy of Mario and Carlo Fortino.)

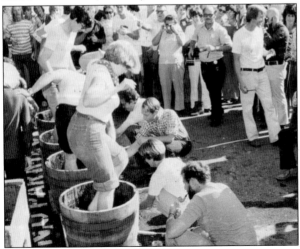

For over 20 years, Mario and Frances enjoyed helping plan the SSCVV biannual festivals, one in the spring and the other in the fall during harvest. These festivals drew crowds upward of 1,000 people over the two-day weekend. The festivities included food, wine, live music, and grape-stomping contests. Mario can be seen holding a camera, center-right of the photograph. (Courtesy of Mario and Carlo Fortino.)

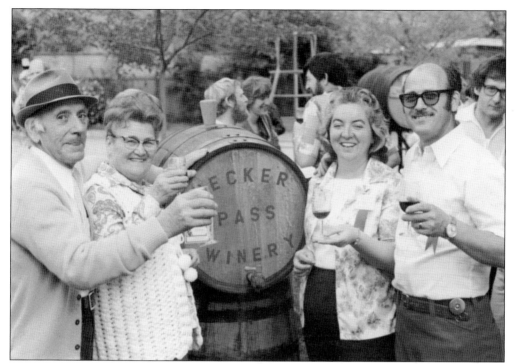

Mario's parents, Michael and Teresina (left), salute the success of Mario and Frances's Hecker Pass Winery at one of the SSCVV festivals. (Courtesy of Mario and Carlo Fortino.)

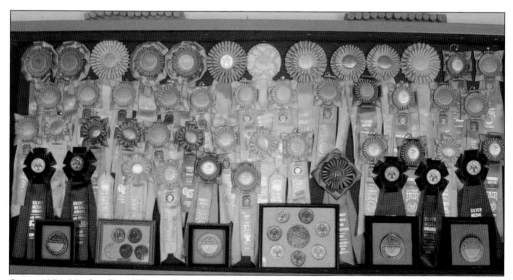

Since 1974, Hecker Pass Winery has garnered over 170 state and national wine competition awards. Today, these ribbons and medals are proudly displayed in Mario and Carlo's tasting room, and the excellence in producing award-winning wines continues. (Author's collection.)

Today, Mario and his son Carlo share the responsibilities of running the winery. Hecker Pass Winery specializes in rich red wine, including Petite Sirah, Zinfandel, Carignane, and Chianti. The wines on their wine-tasting menu are organized according to white, medium-dry, dry, sweet, and dessert, so it is easy for people to make a selection. The tasting room has second-generation customers, grown children of older customers coming on their own. Carlo manages La Vigna, the winery's event center. La Vigna is open year-round for weddings, anniversaries, corporate events, birthdays, and any other celebration or event. An indoor banquet room leads to an expansive covered outdoor patio and open dance floor. Views of their 12-acre vineyard and surrounding hills, along with a private bridal room, makes La Vigna a spectacular venue for a most memorable event. (Author's collection.)

Four

FERNWOOD CELLARS

Passed down through six generations of the same family for over 150 years, Fernwood Cellars is situated on the oldest continuously owned property among all the existing wineries in the Santa Clara Valley.

In 1863, Charles and Annis Sanders were the first generation to settle on 160 acres of lush redwoods in Pleasant Valley (now Gilroy), California. Charles and Annis were natives of Nova Scotia, Canada, and after striking out in the California Gold Rush of 1849, they struck it rich with the newly enacted Homestead Act of 1862. Charles and Annis fenced the property, built a three-room cabin, and planted the first of many grapevines.

In 1891, Charles Sanders built a hotel called Redwood Retreat, a metaphysical resort for tourists to relax and meditate among the bubbling creek and giant redwoods. A spiritualist, Charles conducted séances at the hotel to communicate with those who had passed over to the other side. The three miles of scenic road leading to the property and other homes along the way still bear the name Redwood Retreat Road.

When the hotel burned down in 1908, it was quickly replaced with a lodge and wood and tent cabins near the creek. Hundreds of visitors came to enjoy the beauty of the redwoods and fish for steelhead salmon. The lodge was taken care of by the Sanders' children and grandchildren until it was closed during the Great Depression. Over the years, the lodge and cabins fell into disrepair.

In the 1990s, Linda Pond (Oetinger), the fourth generation, built a multi-generation house on the property with her mother and restored the old lodge and two remaining cabins.

After Matt Oetinger, the Sanders' great-great-grandson and fifth generation, graduated with a degree in biology specializing in viticulture and enology, he designed a vineyard on his family's property. In 1999, he planted vines and soon after opened his winery, Fernwood Cellars.

Fernwood Cellar's flagship wine is their cabernet sauvignon, aged in 100 percent French oak barrels. Matt and his wife, Tiffany, hope to pass down their family's legacy to their children, Jake and Ella, the sixth generation of the Sanders family.

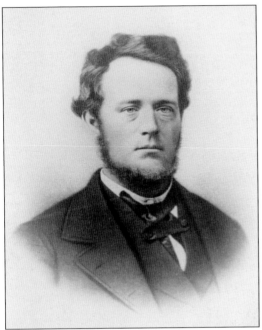

In 1824, Charles E. Sanders was born in Nova Scotia on the eastern coast of Canada. At the age of 25, Charles became one of the famous forty-niners of the 1849 Gold Rush when he traveled to California with his brother Stephen in search of gold. He traveled 17,000 dangerous miles around Cape Horn to reach San Francisco, California. Charles was a spiritualist who believed it was possible to communicate with the spirits of people who had died and passed over to the other side. Hoping to soothe the aching loneliness of the gold miners who had left their families behind, he facilitated and participated in numerous séances. A restless Charles returned to Nova Scotia to marry Annis S. Hilton. But the call of gold compelled him to leave his wife behind in Nova Scotia, and he returned to the gold mines in Susanville, California, promising to send for her. (Courtesy of Linda Pond.)

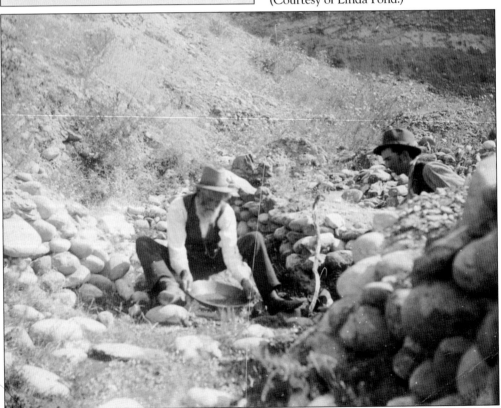

Panning for gold in the 1850s is Charles E. Sanders with a long beard. His pan was preserved and passed down through the generations and is now in the possession of his great-granddaughter Linda Pond. (Courtesy of Linda Pond.)

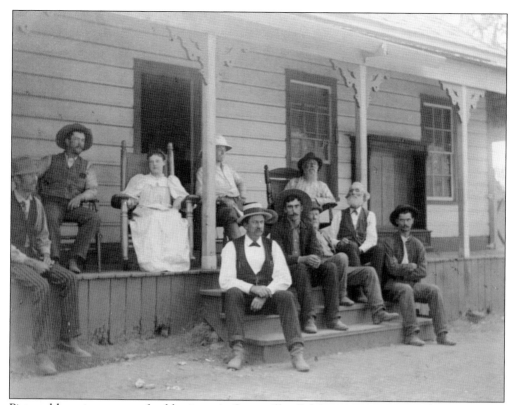

Pictured here is a group of gold miners in Susanville, California, sometime in the 1850s. One of the few women in the mining camps is seen here, probably a miner's wife. Charles Sanders is second from the right. (Courtesy of Linda Pond.)

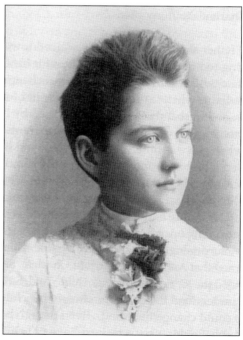

In 1837, Annis J. Hilton was born in Yarmouth County, Nova Scotia. At the age of 16, Annis married 28-year-old Charles Sanders when he made a return visit to his homeland, back from the California goldfields. After only 10 months of marriage, Charles once again left for California. In the spring of 1854, after two long years of waiting, Annis was determined to join Charles in California. Instead of going around the Horn as Charles had done, Annis traveled across the Isthmus of Panama, a three-month journey by dugout canoe, horseback, steamboat, and stagecoach before finally reaching the mining camp of Susanville, California. Before long, Annis contracted tuberculosis, which ran rampant among the miners. Despite her poor health, Annis gave birth to two sons, Wilburn and Irville. After moving to a homestead in Gilroy, California, Annis died at the age of 26, giving birth to her only daughter and namesake in 1863. (Courtesy of Linda Pond.)

Pictured here is the three-room home along Sanders Road (later called Redwood Retreat) in 1863. In *A Cabin in the Hills*, Allan Bosworth wrote, "The feeling of leisure begins when you have left the broad, striped highway for a more humble road. This one is paved, too, but it did not thrust the hills aside in majestic haste to get somewhere. It conforms to the earth instead, meandering by way of meadow and vale. Originally, it was laid out by a man who climbed to the seat of a wagon, shook the reins over the backs of his horses, and then dozed." (Courtesy of Linda Pond.)

This is a formal portrait of Annis Sanders, taken about 1860. Annis wrote in her diary on December 10, 1863, "Well, I do not think I will be with my little family another New Years. The babe's due any time now. And you see, I am not dead yet but my health is very poor and I am unable to do anything. I am quite discouraged. Oh mother and father, I know now I shall never see you again. Adieu." Annis died soon after giving birth to her daughter, also named Annis, but nicknamed "Gypsy." (Courtesy of Linda Pond.)

Not knowing how to raise a baby, Charles Sanders wrapped his newborn daughter Annis in a blanket and took her by horseback to Miller and Lux (the largest cattle producer in California) on Mount Madonna. The Indian women who lived there wet nursed Annis until she was three years old, at which time she returned to live with her father, brothers, and new stepmother, Alphonsine Pond. This photograph shows Annis at three years old with Alphonsine. (Courtesy of Linda Pond.)

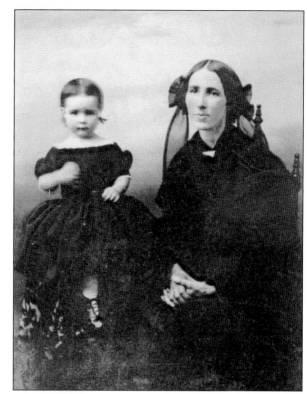

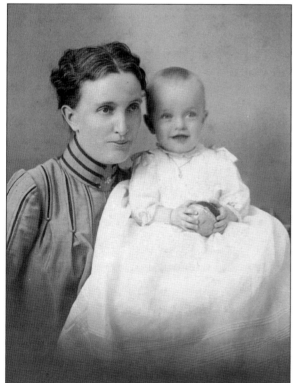

Charles nicknamed his daughter "Gypsy," for her dark and wavy hair. She bore an uncanny resemblance to her mother and played up the striking similarity by wearing her hair in the same style. Gypsy grew up and married Brayton Pond, her stepmother's brother, who was 35 years her senior. Together they had a son, Charles Pond, pictured here with his mother. (Courtesy of Linda Pond.)

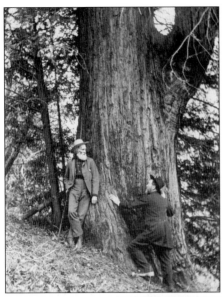

Here is Charles Sanders around 1870, leaning against an old-growth redwood tree on his homesteaded property. His brother Stephen Poole Sanders, climbing up to join Charles, was a professional photographer, one of the reasons there are so many good photographs of the family. (Courtesy of Linda Pond.)

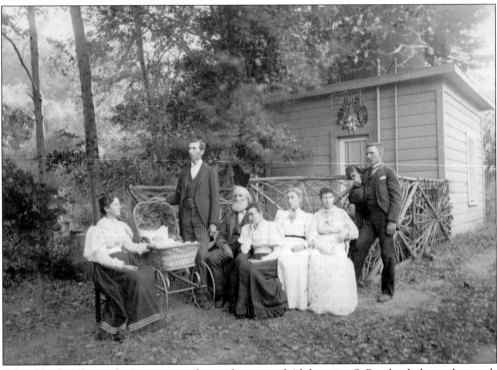

After Charles's first wife, Annis, passed away, he married Alphonsine S. Pond to help on the ranch and provide a home for his three children. This 1870s photograph is taken in front of the tank house. The tank house held the water for the resort and guest use, as well as for emergency use if a fire broke out. The family is gathered with Charles, sitting third from left. To Charles's left is his son Wilburn and his wife and baby. Seated in front of Charles is his daughter Annis, named after her mother who died in childbirth. To Charles's right is his new wife, Alphonsine, and far right is Charles's son Irville and his wife seated to his left. This tank house was built to last and is still holding strong on the property, located across from the winery. (Courtesy of Linda Pond.)

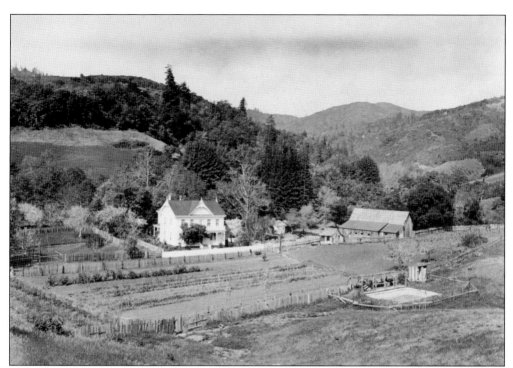

In 1891, Charles built a beautiful Victorian structure he called Redwood Retreat Hotel, and people from San Francisco and beyond traveled to relax among the majestic redwoods. The resort was described by the *Gilroy Gazette* as "one of the best places for rest and meditation in the state." The hotel had 20 bedrooms and the first outdoor swimming pool in Santa Clara County (only the second outdoor swimming pool in all of California). The swimming pool was made out of sand bags covered with concrete. The nearby creek went in one end of the pool and out the other, making the water extremely cold. (Courtesy of Linda Pond.)

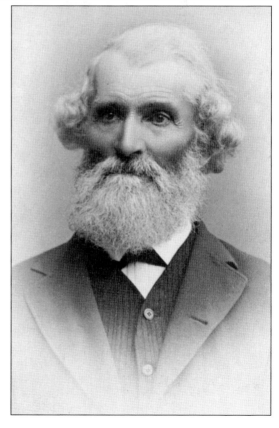

Charles was heavily involved in the mystical spiritualist movement and participated in many séances at the hotel until he passed away in 1906. Two years later, on July 4, 1908, a kitchen fire burned the hotel to the ground, and 44 guests were evacuated, all unharmed. (Courtesy of Linda Pond.)

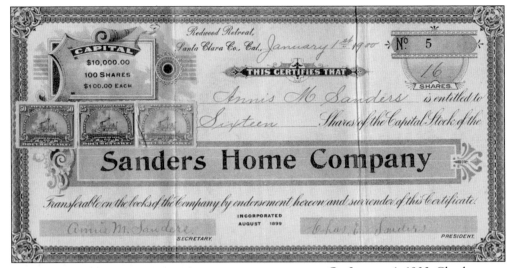

On January 1, 1900, Charles Sanders gave his daughter Annis M. Sanders 16 shares of the capital stock of the Sanders Home Company, worth $1,600. This was a significant amount, considering the average income for an American supporting a family in 1900 was around $1,200 a year. (Courtesy of Linda Pond.)

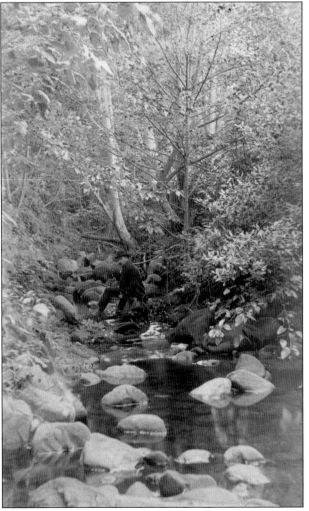

The beauty of the creek was a main attraction for visitors. To this day, it is a picturesque stream that never runs completely dry as it meanders past the resort's lawn tennis area, where Fernwood Cellars sometimes holds events. An unidentified man is enjoying the peace and tranquility of the creek beneath the forest canopy. (Courtesy of Linda Pond.)

A group of
vacationers relax
by the side of the
bubbling creek.
Charles Sanders,
the owner of this
idyllic resort, is
sitting on a fallen
tree branch
in front of the
group. (Courtesy
of Linda Pond.)

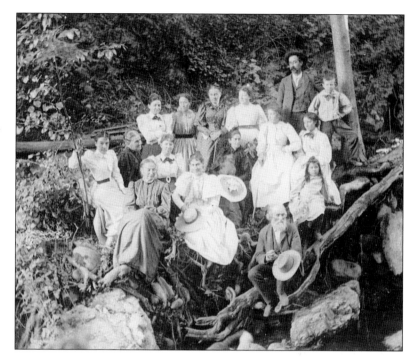

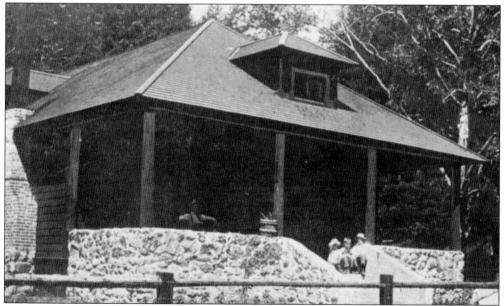

After the Redwood Retreat Hotel was destroyed in the 1908 fire, it was immediately replaced with a lodge-style building surrounded by a dozen cabins along the creek, some made of wood and others were tent cabins affixed to a wooden platform. The great lodge served as a gathering place for the 30 to 40 vacationing guests. Dinner was prepared in the huge kitchen with someone clanging a metal plow shear (still hanging in the giant oak next to the back door) when it was time to eat. After dinner, people played gin rummy by the light of the fireplace in the lodge's great room. (Courtesy of Linda Pond.)

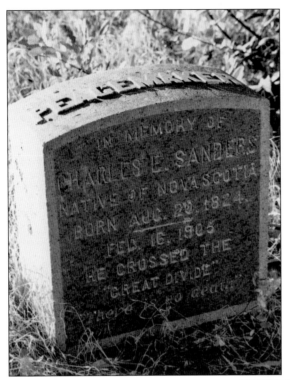

Before Charles Sanders died in 1906, he ordered Nova Scotia granite to be used for his headstone. His headstone was inscribed "Peacemaker," "He crossed the great divide," and "There is no death." The granite is so polished that it is free from any moss and looks as new as the day it was made. Charles is buried in the family cemetery on the neighboring Vanumanutagi Ranch, which was once part of the Sanders family homestead. Fanny Stevenson, wife of Robert Louis Stevenson, purchased the land from Charles, and the family cemetery was excluded from the deed. Charles's first wife, Annis, is buried next to him, and Alphonsine is buried nearby, along with many guests who wanted to be buried there. (Courtesy of Linda Pond.)

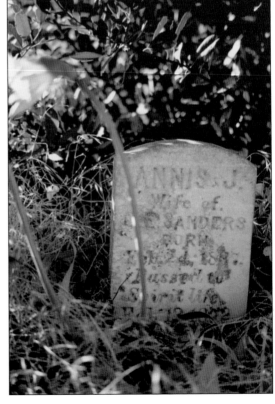

This is the headstone for Annis Sanders. Her husband, Charles, strongly believed in an afterlife, and despite the fact that Annis never subscribed to the same beliefs, he ordered a headstone for her that says, "Passed to Spirit Life." (Courtesy of Linda Pond.)

The creek on the Redwood Retreat property is one of only two remaining steelhead spawning streams in all of Santa Clara Valley. This group of proud anglers shows off their salmon catch of the day, which they undoubtedly cooked up for dinner that very evening. (Courtesy of Linda Pond.)

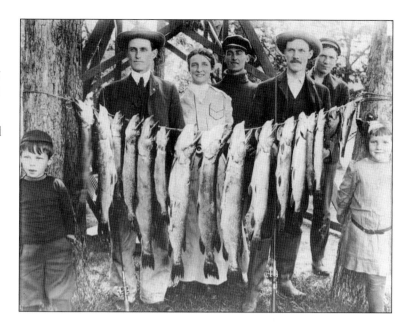

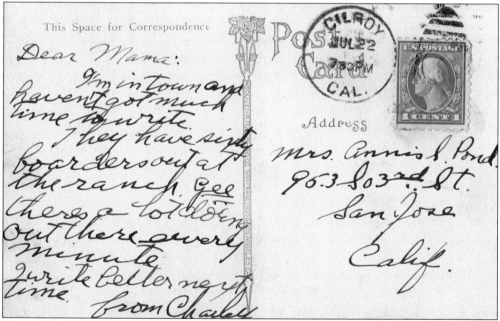

Brayton Pond only lived long enough to see his son Charles "Charley" turn two years old. After Pond passed away, Gypsy took Charley and moved out to San Jose. When Charley became a young man, he, along with his cousins, helped out at the ranch. This postcard, written by Charley to his mother, expresses his lack of free time. With "sixty boarders out at the ranch, gee, there's a lot doing out there every minute." This postcard was likely written in the late 1920s, when the price of mailing a postcard was 1¢. (Courtesy of Linda Pond.)

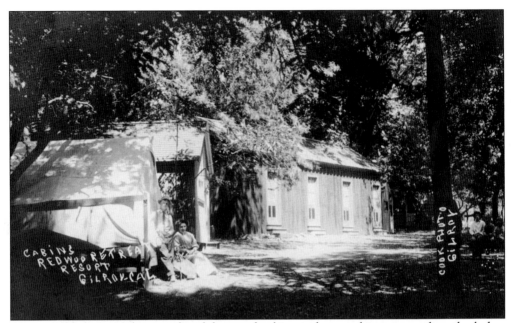

Above and below are photographs of the wood cabins and tent cabins surrounding the lodge. (Both, courtesy of Linda Pond.)

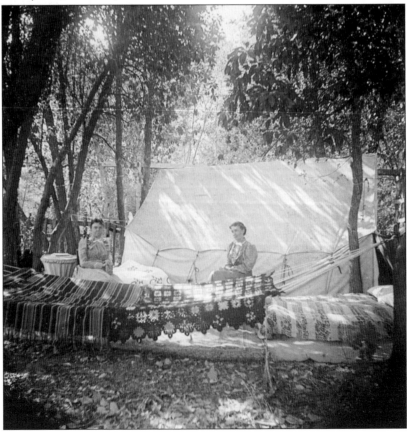

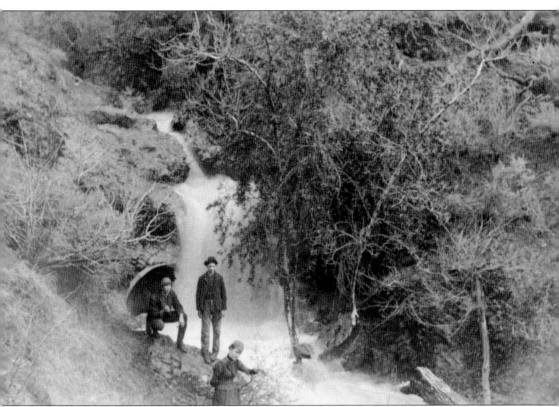

Here are the three children of Charles and Annis Sanders, Wilburn (with the umbrella), Irville, and Gypsy, on their ranch property. The photograph was taken on a winter's day at the headwaters of Little Creek near Big Oak, which runs across the road and under the washhouse, where laundry was completed and visitors showered. Wilburn, Irville, and Gypsy operated the Redwood Retreat Resort until the Great Depression hit in 1929. With unemployment as high as 25 percent, few people could afford a vacation at the resort. Gypsy retained ownership of the property, but she was forced to close the lodge and cabins. (Courtesy of Linda Pond.)

Charles Denio Pond, the only child of Gypsy and Brayton Pond, married Elsie Malek in 1930. These photographs were taken near the time of their marriage, when he was about 27 and she was 22. The young honeymooners had only been married for six months before Charles came down with tuberculosis and was given only six months to live. Because TB is highly contagious, the newlyweds moved to Redwood Retreat, where they lived in two separate cabins. Every day, Elsie faithfully delivered food to the front steps of his cabin. They endured this cruel situation for five years, from 1931 to 1936. (Both, courtesy of Linda Pond.)

Finally recovered, the young couple moved to San Jose, and six years later, their only child, Linda, was born. Charles and Elsie Pond returned to vacation at Redwood Retreat while renting out the great lodge at the same time. In this 1943 photograph, Elsie is holding her baby daughter, Linda, by the swimming pool, while an unidentified boy swims in the background. As time went on, the family spent less and less time at the resort, and the buildings fell into disrepair. In the 1960s, trespassers burned down the remaining cabins. (Courtesy of Linda Pond.)

Linda and her father, Charles, would often climb to an outlook above the swimming pool, where they talked of one day building a home. "After I die, bring your mother back here where we started," Charles would say. Linda fulfilled her father's wishes by building a two-story, three-generational home with her mother, then 83 years old. Linda restored the great lodge, two cabins, and the Sanders' family homestead. In addition, Linda and her son Matt replanted the vineyards with Cabernet Sauvignon, Zinfandel, Syrah, and Petit Verdot and established a new irrigation system. Linda and her second husband, Kevin Godden, are pictured here right before harvest in 2014. (Courtesy of Linda Pond.)

The fifth generation is represented by Charles Matthew "Matt" Oetinger, the only child of Linda Pond and Lew Oetinger. In the mid-1990s, equipped with a major in biology from UC Davis, Matt became vineyard manager at Clos LaChance Winery, which at that time was located in Saratoga, California, at the old Congress Springs Winery. By 1999, Matt established Fernwood Cellars on Redwood Retreat land. Matt and his wife, Tiffany, operate their family business while raising their two children, Jake and Ella. They only make wine from grapes that they grow or manage and never use oak alternatives. Instead, they use the best oak barrels they can find in order to make consistently fine wine. In addition to their tasting room in Gilroy, in June 2014, Fernwood Cellars opened a new tasting room in downtown Los Gatos called Vines of Los Gatos. This family photograph of both the fifth and sixth generations was taken in the estate Cabernet vineyards in 2009. (Courtesy of Linda Pond.)

Five

SOLIS WINERY

One of Santa Clara Valley's most popular wineries is Solis Winery, formerly Bertero Winery, on Hecker Pass Highway in Gilroy. Located just a few easy miles from downtown Gilroy, the winery and its 16 acres of vineyards are pressed against the lush, scenic hills that rise up behind it.

After Alfonso Bertero emigrated here from Turin, Italy, he founded the Bertero Winery in 1917. Alfonso sold wine for religious purposes during Prohibition but soon turned to bootlegging after realizing how profitable it was. Wanting to show off his newfound wealth, he built a home with crushed abalone shells on the outside walls so that it would sparkle in the sunlight. This home is still standing next to the winery and visible from the roadside.

Alfonso retired when he was 76 years old and passed the business to his son Angelo. Angelo continued to run the winery, along with assistance from his two sons Angelo Jr. and Carl. During this time, the Bertero Winery developed a reputation for strong jug wines and established one of the region's first dedicated tasting rooms. But instead of Angelo Sr. passing the winery down to his sons as planned, he changed his mind and sold the winery and land to another family. Legal issues ensued with the family over the contract, and the winery was again sold, this time to the Vanni family. They renamed their winery Rancho de Solis, a reference to an 1830s Mexican land grant west of Gilroy.

David and Valerie Vanni purchased the winery in 1989 and started fresh, with new plantings, including Chardonnay, Merlot, Muscat Canelli, Zinfandel, Sangiovese, and Cabernet Sauvignon.

David and Valerie's sons Michael and Vic joined the family's winery business after completing their degrees in agriculture from California Polytechnic State University. Michael learned the art of winemaking while Vic took over sales and operations. In 2007, David and Valerie retired and passed along the winery to Michael and Vic.

Today, Solis Winery produces a wide range of award-winning wines and specializes in rich red blends and Italian varietals such as Barbera, Sangiovese, and Fiano.

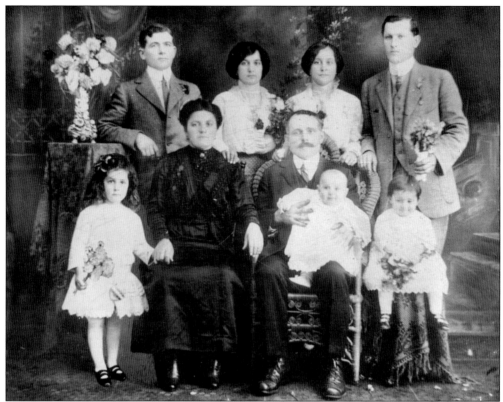

In 1879, Alfonso Bertero was born in Turin, Italy, and he emigrated to the United States in 1911. Alfonso married Maria, also from Italy, and had three children: two daughters, Sundrina and Justina, and a son, Angelo. This photograph was taken at Angelo's baptism in 1914. From left to right are (first row) Justina, Maria, Alfonso holding Angelo, and Sundrina; (second row) unidentified first cousin of Maria, Angelo's godmother Mary Ottavino-Piastri, and two other unidentified first cousins of Maria. (Courtesy of the Bertero family.)

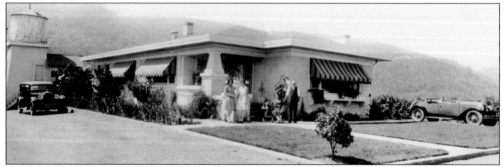

In 1917, Alfonso founded his winery in Gilroy and, during Prohibition, ran his wine business from the secret basement of his house. To show off his wealth, Alfonso had his house sprayed with sparkling abalone shells. One day, federal agents stopped by and gave Alfonso a choice: either pay them $2,000 and they would never bother him again, or they would dump out all his wine. Alfonso paid them off. His neighbor, Peter Scagliotti of Live Oaks Winery, refused to pay and had all his wine dumped out on that very same day. From left to right are the Berteros' two daughters Justina and Sundrina; Maria; Alfonso; and son Angelo Sr., sitting in the family car. (Courtesy of the Bertero family.)

The Abalone House is still standing next to the Solis Winery, visible to passing motorists on Hecker Pass-Highway 152 in Gilroy. Alfonso was always proud to note that he dug the secret basement by himself with only the help of a plow horse. (Both, author's collection.)

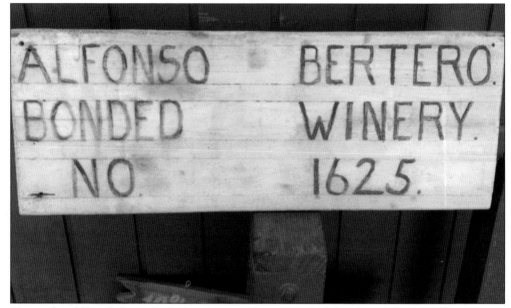

Here is the old bonded sign for Alfonso's original winery, which he obtained in 1917. Wineries are required to be bonded, which means that they guarantee to pay their fair share of federal excise tax. The tax is based on the total potential volume of wine they may have stored on their site during any given month of the year. Also, it is based on the wine's alcohol content. In general, wines with higher alcohol content are charged a higher excise tax. For example, still wine 14 percent and under is taxed at $1.07/gallon, still wine over 14 percent but not over 21 percent is taxed at $1.57/gallon, and sparkling wine is taxed at $3.40/gallon. (Author's collection.)

The original bottle corker that Alfonso Bertero hand carved and hand made in the early 1900s greets visitors in the entryway of the Solis Winery tasting room. In order to work this bottle corker, the first thing to do is to place a cork in the mechanism, position the bottle correctly, and pull the lever down until the cork is fully inserted. (Author's collection.)

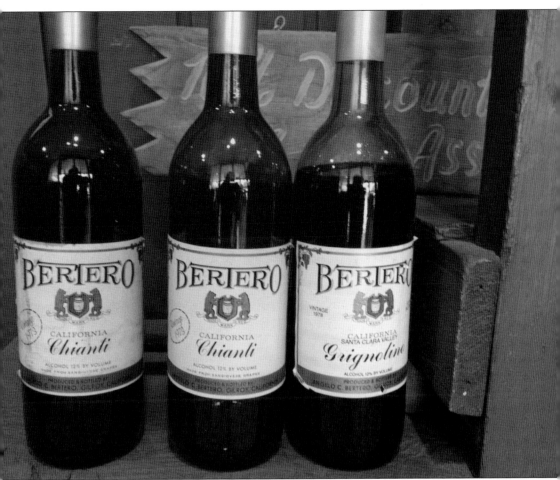

The Bertero Winery produced bold-tasting table wines made from Old World, low-technology methods. In addition to Zinfandel, Carignane, Grenache, French Colombard, Grenache Rose, and Chianti, the Berteros produced a highly regarded Grignolino. Grignolino is a red-wine grape from the Piemonte region in Italy. The word *grignole* means many pips or seeds, which contributes to the grapes' strong, bitter tannins. With the proper winemaking techniques, this grape produces light-colored roses with fruity aromas and balanced tannins. The Berteros usually sold their wines in large glass containers, although they could also be bottled on special order. (Author's collection.)

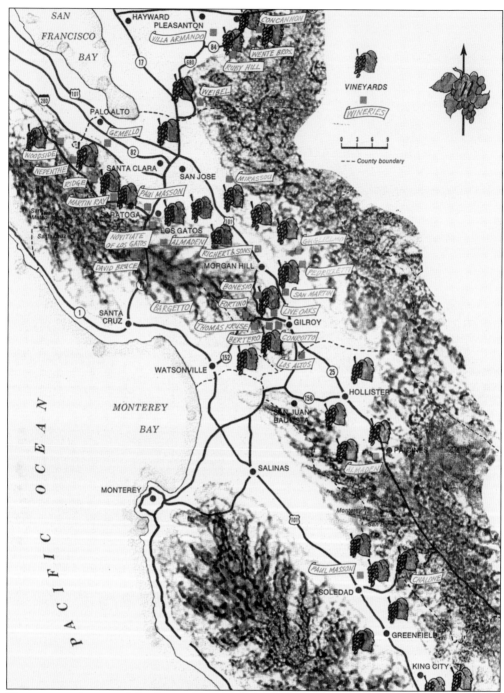

This is an early map of the Santa Clara Valley winery region from around 1970. There were relatively few wineries compared to the number that exist today. Some of these wineries closed years ago, while many like Bertero (now Solis), Bonesio (now Kirigin), Fortino, and Guglielmo are still thriving. (Courtesy of the Vanni family.)

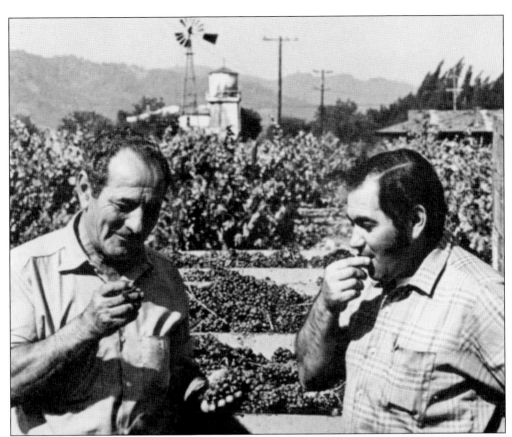

This photograph of Angelo Sr. and his son Angelo Jr. was taken in their vineyard in the 1970s. Behind them to the left is the shop, garage, and water-tank house with two sleeping quarters upstairs. At right is Alfonso Bertero's abalone house. (Courtesy of the Bertero family.)

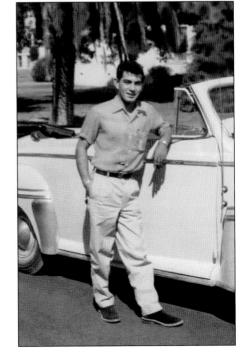

Here is a photograph of Angelo Jr., nicknamed "Doll" when he was a baby because of his long eyelashes. Doll is pictured here around 1955, when he was about 20 years old, standing proudly by one of his first cars. (Courtesy of the Bertero family.)

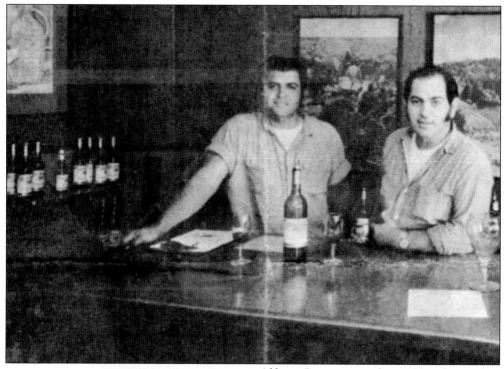

Alfonso Bertero retired in 1955 and turned over the winery to his son Angelo Bertero Sr. He had two sons, Angelo Jr. and Carl, who assisted him in running the winery for many years. This photograph is of Carl (left) and his brother Angelo Jr. (right). (Courtesy of the Bertero family.)

Angelo Jr. earned his business degree from San Jose State University and kept the winery books in addition to being the general manager of Bertero Winery. He was particularly business savvy and persuaded his father to open one of the first pavilion-style tasting rooms in the region. They built their tasting room in 1972, after purchasing an old sales office from a new housing project in San Jose, hauling it down in three sections. Then they bought the tasting bar from the Logan Winery in San Jose that was going out of business, and it fit perfectly. This photograph accompanied a news article from September 1977 about the 10th Annual Bonanza Days, a nonprofit event in Gilroy. Angelo Jr. was the president of that year's planning committee. (Courtesy of the Gilroy Dispatch.)

In 1980, Angelo Sr. inexplicably sold the winery instead of passing it down, as promised, to his two sons. Losing the winery was a major disappointment to Angelo Jr., who had hoped to carry on the legacy of his family's wine business. (Courtesy of the Bertero family.)

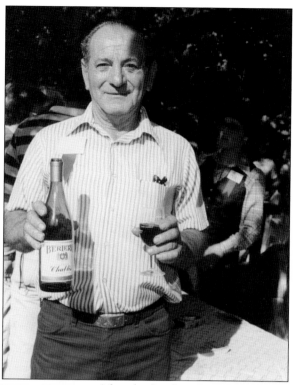

After the family winery was sold, Angelo Jr. changed careers and opened a distributorship called Buena Vista Barn Company, which he managed until his retirement in 2004. Andrea, his daughter, remembers him as a very loving and protective father who called her "Baby" even when she became an adult. Angelo died from skin cancer in 2010 at the age of 75. After numerous failed attempts at pregnancy, Andrea and her husband, Mark Noriega, were pleasantly surprised when Andrea became pregnant, just one month after Angelo Jr., her father, passed away. When Andrea and Mark's daughter was born, she bore a strong resemblance to her grandfather, and they named her Tiffany Angelo, in loving memory of him. This photograph is of Angelo Jr. at his daughter's wedding, where he served wines from his good friends' winery, Guglielmo Winery. (Courtesy of the Bertero family.)

In 1980, David and Valeri Vanni moved from Los Altos to Gilroy to be closer to their cut-flower business in Watsonville. They purchased five acres of land adjacent to the old Bertero Winery and vineyards, and they nestled their home in the foothills. The Vannis' land included a vineyard of their own, and they produced a few barrels of Vanni Blend in their basement. (Courtesy of the Vanni family.)

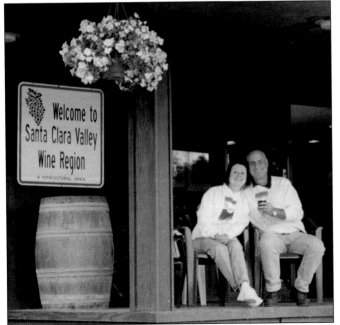

In 1989, the Bertero Winery passed into the Vanni family's hands to become Solis Winery. David Vanni started fresh, with new plantings, and renamed their winery Rancho de Solis in reference to an 1830s Mexican land grant west of Gilroy. David and Valerie renewed the grounds and wine tasting room. David and Valerie are seated in front of their tasting room welcoming visitors to the Santa Clara Valley Wine Region. (Courtesy of the Vanni family.)

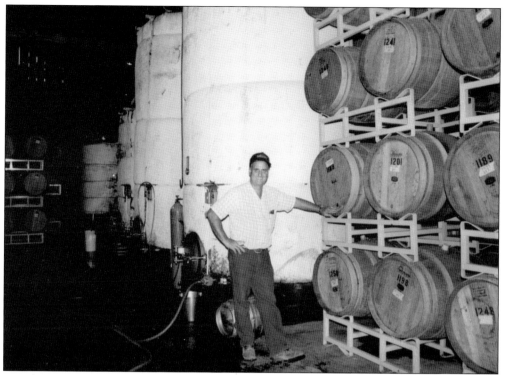

David Vanni poses with his wine barrels and storage tanks. (Courtesy of the Vanni family.)

As the bottles of wine come off the bottling line, they are placed in cases of 12. Here, Don Vanni, David's brother, applies the Solis label to a box. (Courtesy of the Vanni family.)

David's son Michael pitched in around the winery after college and is shown here next to the bottling line, sometime during the late 1990s. (Courtesy of the Vanni family.)

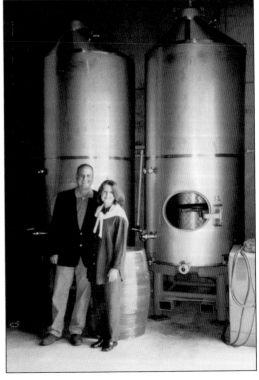

David and Valerie Vanni stand in front of two steel tanks, which are used to age wines when flavors that are normally imparted from oak barrels are not desired. The wines that the Vannis age in their steel tanks include Chardonnay and Vino Roseo di Sangiovese. These two tanks are still used today. (Courtesy of the Vanni family.)

This crusher/de-stemmer machine was state of the art in the 1990s. After the grapes were picked, they were hoisted above and dropped into the machine. First, the machine gently crushed the grapes, breaking open the skin and allowing the juice to run out. Next, the machine removed the stems from the grapes, as seen in the photograph at right. (Both, courtesy of the Vanni family.)

The lush grounds and rows of vineyards offer the perfect backdrop to private wine club dinners and other public events such as Cigars Under the Stars, Syrah and Sausage, and wine and cheese pairings, which are held throughout the year. (Courtesy of the Vanni family.)

In the early 2000s, David Vanni's two sons Mike (left) and Vic (right) had finished their degrees in agriculture and eventually joined their father's wine business. Mike came along first, as everyone's assistant, while getting on-the-job training in winemaking. In 2007, when their father was ready to retire, the brothers jumped at the chance to take it over: Mike as winemaker and Vic on the business side. Solis Winery features a selection of award-winning California wines, including Cabernet Sauvignon, Merlot, Chardonnay, Syrah, Sangiovese, Fiano, and Zinfandel. All of these are available to be sampled in their tasting room, which is open every day. (Author's collection.)

Six

FORTINO WINERY

The Fortino family story is a classic American dream story. Ernesto Fortino was just 23 when he immigrated to the United States in 1959. Ernesto left his hometown of Calabria, Italy, where his family made bricks from the earth and grew wine grapes on their property. Not speaking a word of English but looking for a better way of life in America, Ernesto eagerly accepted work in the canneries and vineyards of Santa Clara Valley.

Ernesto met and married Marie Cardinale and soon had their first child, a son named Gino. Needing more money to support his growing family, Ernesto asked his boss for a raise, and he was promptly fired.

Driven to succeed, Ernesto had impressed others with his hard work and friendly personality and was asked to be a partner in a wine shop. Although ultimately unsuccessful, this wine shop experience gave Ernesto valuable skills in running a business.

When the old Cassa Brothers Winery, founded in 1948, came up for sale, Ernesto, along with his brother Mario, seized the opportunity to purchase it and named it Fortino Brothers Winery. Two years later, the brothers dissolved their partnership, and Ernesto became the sole owner, changing the name to Fortino Winery.

Ernesto, or Ernie as he is affectionately known, along with his wife, Marie, worked long and hard hours to make their winery a success. In 1978, they established one of the very first wine clubs in California.

In 1995, when they were ready to retire, the well-established Fortino business was passed to their children, Gino and Teri. Gino's strategic decision to obtain wedding and commercial kitchen permits launched their business to a whole new level, with weddings booked solid from spring through fall.

Fortino Winery has a total of 50 planted acres, including estate Merlot, Cabernet, Carignan, Charbono, Chardonnay, Riesling, and Pinot Noir. Maribella, named after Marie, the family matriarch, is an award-winning red blend.

On any given day, visitors to the winery will find Gino Fortino riding a forklift, inspecting the vineyard, and making sales. Just as likely, visitors will also find Ernesto visiting and reminiscing with his friends in the tasting room.

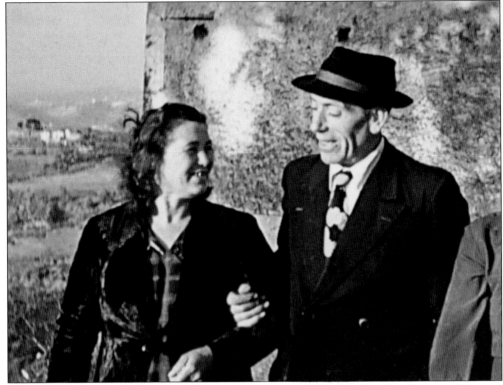

Michael Fortino, pictured here, was born in Kansas in 1905. Michael's father, Giuseppe Fortino, had immigrated to the United States in the late 1800s to work in a Kansas coal mine. After a serious coal mining accident, Giuseppe moved his family back to Italy in 1911. In 1932, Michael Fortino was 27, and he married his sweetheart, Teresina Filice. Their son Ernesto was born in 1936. In 1959, Michael decided to return to the United States and brought his wife and five children, including Ernesto. This photograph is of Michael and Teresina in front of their home in Calabria, Italy, in 1952. (Courtesy of Ernesto and Gino Fortino.)

Ernesto "Ernie" Fortino, the third of five children, was born in Italy in 1936, with dual citizenship in both the United States and Italy. Ernie's family shared a rustic duplex without running water or electricity with his uncle and his family. This photograph shows Ernie when he was 16 years old; he is standing on the steps of his home, with his arm around a young child. He is surrounded by his cousins and younger brother Mario, 14, at the bottom of the photograph. (Courtesy of Ernesto and Gino Fortino.)

When Ernie Fortino was 18 years old, he joined an unnamed band of musicians that walked to neighboring cities to play their music. Back in 1954, when this photograph was taken, entertainment was hard to come by, and live music was always welcomed. Ernie is shown here playing a fine Dallappe accordion. (Courtesy of Ernesto and Gino Fortino.)

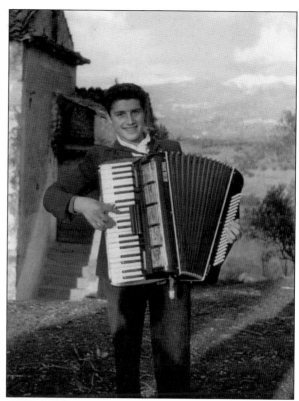

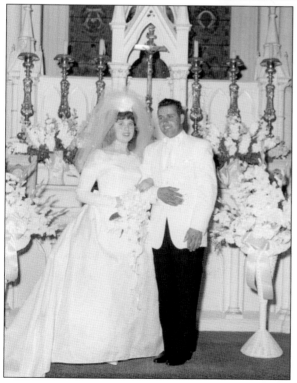

In 1959, Ernie traveled with his family to the United States to follow the American dream. Ernie did not speak a word of English, but with his expertise in pruning grapevines and making wine, he found work at the Filice family's ranch in Gilroy. Ernie met the love of his life, Marie Cardinale, and on April 24, 1964, they married at St. Mary's Catholic Church in Santa Cruz. Although the young couple was happily married, they struggled to make ends meet. When Gino was born in 1966, Ernie asked for a raise at the lumberyard where he worked and was promptly fired. Ernie did odd jobs for his father-in-law and also worked for Bargetto Winery. In 1968, Teri Fortino, Ernie and Marie's daughter, was born in Monterey, California. (Courtesy of Ernesto and Gino Fortino.)

Through his job at the lumberyard, Ernie met two Portuguese brothers who owned a liquor store in Aptos, California. The brothers invited Ernie, who barely spoke English but had experience at Bargetto Winery, to become a partner in a new wine shop in Cannery Row, Monterey. (Courtesy of Ernesto and Gino Fortino.)

While Ernie was working in the Portuguese wine shop, a Beverly Hills attorney inquired about buying a winery. As luck would have it, Ernie soon met an elderly couple who were desperate to sell their run-down Cassa Brothers Winery in Gilroy (founded in 1948). Ernie saw an opportunity, and he had them sign a promissory note for a $10,000 commission on the sale of the winery, payable whether or not the winery sold. When the attorney saw the dilapidated winery, he changed his mind, and the deal fell through. Feeling bad for the elderly couple, Ernie and his brother Mario decided to buy the winery. The elderly couple made Ernie such a good deal that he could not, in good conscience, follow through on the $10,000 promissory note. In 1970, the Fortino Brothers Winery was founded. (Courtesy of Ernesto and Gino Fortino.)

Although it was never used by the Fortino family, this old John Bean orchard sprayer came with the purchase of the property and sits there to this day. The sprayer was built in San Jose in the 1920s and used to spray the previous prune crops with fungicides. It has a 1927 Chevy motor, a Bean pump, steel wheels, and a wooden tank. (Courtesy of Ernesto and Gino Fortino.)

This early-1970s photograph shows a father and his two sons working the land. Michael Fortino is center, with Mario driving the tractor and Ernie on the back end. This tractor was adding nitrogen (fertilizer) to the soil. The Caterpillar D2 was manufactured by Caterpillar Inc. in the factory that was located in Peoria, Illinois. It was introduced in 1938 and was the smallest diesel-powered tractor manufactured by Caterpillar. (Courtesy of Ernesto and Gino Fortino.)

Ernie and Mario opened their Fortino Brothers Winery in 1970. Within two years of joint ownership, the brothers developed separate visions for the business and decided to part ways. That meant dividing the winery and its land into two separate parcels: one parcel included the tasting room building and eight acres of land, and the second parcel, without any building, had 14 acres. With advice from his parents, Ernie chose to take the smaller lot with the tasting room. Mario took the 14 acres and built a winery, called Hecker Pass Winery. The winery changed names in 1972, dropping "Brothers" and becoming Fortino Winery, with Ernie as the sole owner. (Courtesy of Ernesto and Gino Fortino.)

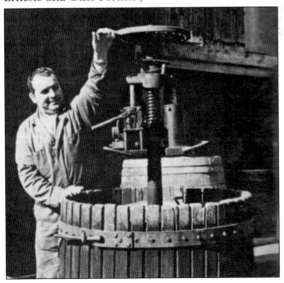

When a wine writer showed up unannounced one morning in 1972, he wanted to take an action shot of Ernie at the winery. But in Ernie's words, there was nothing of interest to photograph at that time. He and the wine writer agreed upon Ernie demonstrating his hydraulic wine press, which was used to press all of his grapes by hand. A half-ton of red grapes could be pressed within two hours. (Courtesy of Ernesto and Gino Fortino.)

Ernie's parents, Michael and Teresina Fortino, lived in Gilroy where they worked in the Filice cannery. Michael would often help Ernie during harvest, pitching in wherever needed. Teresina loved to cook and bake for her family and made Italian cookies such as biscotti, amoretti, and turdilli. Her cookies were so delicious that she had to put a lock on the freezer where she stored them to keep her grandson Gino from eating them all. Most every day, Teresina would have pasta sciutta (a light red sauce made from her homegrown tomatoes) and homemade ravioli simmering on the stove so that anyone could stop in and have a quick meal. Gilroy's current mayor, Don Gage, was Ernie's brother-in-law many years ago and used to love Teresina's fried chicken. From left to right are Michael, Teresina, Marie, and Ernie Fortino. (Courtesy of Ernesto and Gino Fortino.)

Around 1997, at the Harvest Wine Festival held at Filipino Park off Watsonville Road in Gilroy, an unidentified guest (left) and Ernie Fortino (right) enjoy a glass of red wine. (Courtesy of Ernesto and Gino Fortino.)

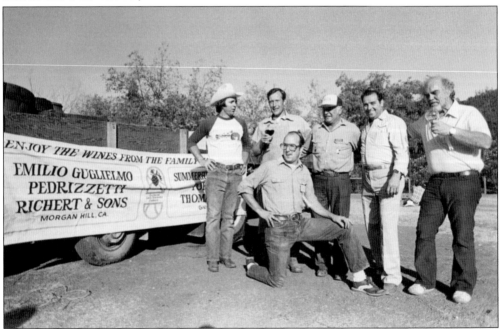

In the 1980s, at another festival held at Filipino Park, new in the crowd was Red Johnson (far right), who purchased the Bertero Winery for a very short time and renamed it Summerhill Winery. From left to right are Gene Guglielmo, Thomas Kruse, Scott Richert (kneeling), Ed Pedrizzetti, Ernie Fortino, and Red Johnson. (Courtesy of Ernesto and Gino Fortino.)

In the mid-1970s, all bottling was done by hand, as seen in this photograph. With this bottling process, up to 2,000 cases could be produced in one season. Contrary to what his parents remember, here is proof that Gino Fortino, the present owner of Fortino Winery, actually worked at the winery when he was just a child. Gino is shown on the far right next to Bernice Alves, their secretary. On the far left is Courtney Childs, a self-described helper-hippie assistant. Ernie Fortino is shown at center. (Courtesy of Ernesto and Gino Fortino.)

This family photograph was taken in the mid-1970s in front of their vineyard in Gilroy. Ernie and Marie are standing while their two children, Gino (left) and Teri (right) sit on the truck. In 1995, Ernie passed on the responsibilities of running the winery to both his children. (Courtesy of Ernesto and Gino Fortino.)

The Fortino Winery was one of only 240 bonded wineries in all of California (presently there are close to 5,000) when it started. A newcomer on Hecker Pass Road, Ernie focused on varietal wines rather than blended jug wines. Ernie's winery was also one of the very first wineries in the region to create a wine club, offering their customers wine discounts and invitations to exclusive events. (Courtesy of Ernesto and Gino Fortino.)

In order to produce more wine, Ernie needed more grapes. In 1979, Ernie and Marie purchased a ranch in San Martin, bringing the total of planted acres to 50. This photograph was taken of Marie and Ernie in 1982 when they planted Chardonnay, Riesling, Pinot Noir, and Charbono wine grapes on their new property. Marie Fortino was a true partner in the winery's success and worked long hours alongside Ernie for many years. In Marie's honor, the family produces their signature red wine blend, called Maribella (beautiful Marie in Italian), which consistently garners medals, including Best of Class in the San Francisco Chronicle Wine Competition in 2013. Ernie and Marie celebrated their 50th wedding anniversary in April 2014. (Courtesy of Ernesto and Gino Fortino.)

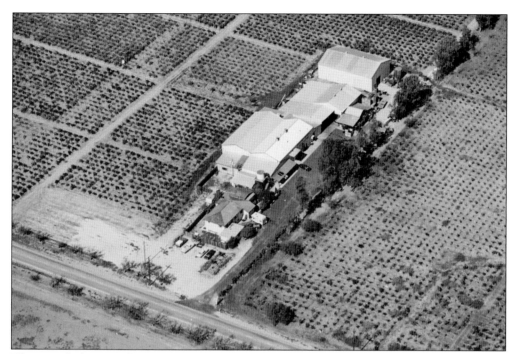

This aerial photograph was taken in 1984. At the bottom of the photograph is Hecker Pass Highway. Up from the highway are the parking lot and house where the Fortino family lived until 1982. Beyond the family home is the tasting room, warehouse, bottling line, and cellar for a combined total of 16,000 square feet. Surrounding the buildings are 28 acres of vineyards. Within the Santa Clara Valley, Fortino Winery has a total of 50 planted acres, including estate Merlot, Cabernet, Carignan, Charbono, Chardonnay, Riesling, and Pinot Noir. (Courtesy of Ernesto and Gino Fortino.)

This photograph of the tasting room building was taken after 1989. The date is easy to determine because the building used to have a tiled roof overhang above the door to the left of this image. The tiles were shaken down during the 1989 Loma Prieta earthquake, one of the largest recorded in the San Francisco Bay Area region, measuring 6.9 on the Richter scale. (Courtesy of Ernesto and Gino Fortino.)

Although responsibilities for the winery were passed down in 1995 to both Fortino children, Gino and Teri, Teri spends most of her time devoted to her real estate business while Gino runs the day-to-day operations of the winery. Gino's strategic decision to obtain wedding and commercial kitchen permits launched the business to a whole new level. In addition to managing the winery, Gino cooks all of the pasta and pizza dishes for the winery events, using his family's traditional Italian recipes. (Courtesy of Ernesto and Gino Fortino.)

Seven

MORGAN HILL CELLARS

Morgan Hill Cellars celebrated their 100th anniversary in 2013, after being owned by three consecutive Italian families: the Colombanos, the Pedrizzettis and now the Sampognaros.

The winery was founded in 1913 by Camillo Colombano, an Italian immigrant, after he smuggled Barbera rootstock hidden inside his boots with the purpose of starting a vineyard. When Camillo retired in 1945, he sold his winery to John Pedrizzetti, also an Italian immigrant and a local farmer, who renamed it Pedrizzetti Winery. And then in 2006, when the Pedrizzetti family was ready to retire, they sold the winery to Mike and Maryclaire Sampognaro, the current owners.

The winery survived Prohibition, a serious frost in the winter of 1979 that wiped out much of the vineyard, and a devastating fire in 1996 that destroyed over half the winery. The three families gave their heart and soul to keep the winery going, relying heavily on hard, physical labor; family help; and extreme perseverance.

The first tasting room did not open until 1968—55 years after the winery was originally founded. Before the tasting room was opened by Ed and Phyllis Pedrizzetti, grapes were sold by the ton to the big, established wineries such as Paul Masson Winery in Saratoga or simply peddled on the roadside. In the early days, customers would bring their gallon jugs to be filled with either red or white wine. Later, wine was sold by the case and delivered directly to private homes or restaurants.

Now the winery boasts a tasting room with a two large tasting bars and a gift shop adorned with hanging tapestries. The tasting menu is grouped into three categories of white, red, and specialty wines (fruit and port wines). Outside the tasting room is a beautiful patio covered in grapevines, perfect for a picnic or special celebration. Morgan Hill Cellars is one of the few wineries that does not charge a tasting fee.

Maryclaire and Mike Sampognaro, the new owners of Morgan Hill Cellars, are members of the Wineries of Santa Clara Valley Association and recently championed the new Wine Trail signage throughout the region.

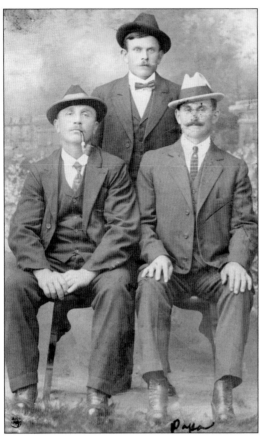

Born in 1883 in the Piemonte region of Italy, Camillo Colombano emigrated to the United States with his brothers in the early 1900s. The brothers, carrying grapevine cuttings hidden in their boots, came through Ellis Island. The brothers are shown in this photograph, from left to right, (seated) Eligio and Camillo; (standing) Pietro. The brothers left a life of poverty in Italy, where they worked for neighbors picking crops. Their living quarters were the upstairs of a small barn, which housed their farm animals underneath. Their beds were bags of hay. (Courtesy of Ernesto Pavese.)

Camillo was fair haired and blue eyed, and at six foot four inches he was always the tallest man in a group. Camillo found a job in Connecticut but did not like the work. He headed to San Francisco after the 1906 earthquake and found a job delivering wine and brandy in a horse and buggy. (Courtesy of Ernesto Pavese.)

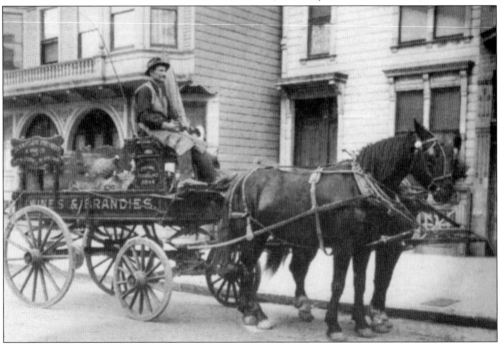

This photograph is of Camillo Colombano, his wife, Luiccia, and their first child, Theresa, taken around 1900. They had two other children, a son Edward and another daughter Eda. (Courtesy of Ernesto Pavese.)

Camillo and his brother Eligio first planted grapevines in Geyserville. Later, Camillo moved to Morgan Hill where he started with 10 acres. Camillo kept buying land as he could afford it and ended up with 80 acres. He founded Colombano Winery in 1913 and planted acres of Barbera from root stock that he brought over from Italy. (Courtesy of Ernesto Pavese.)

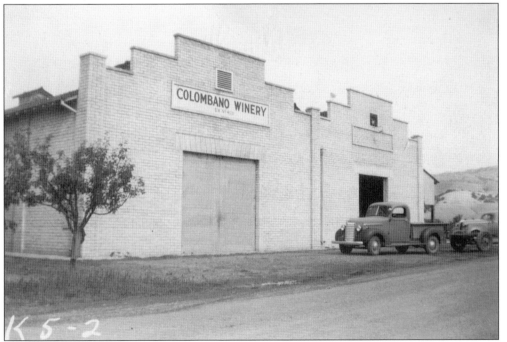

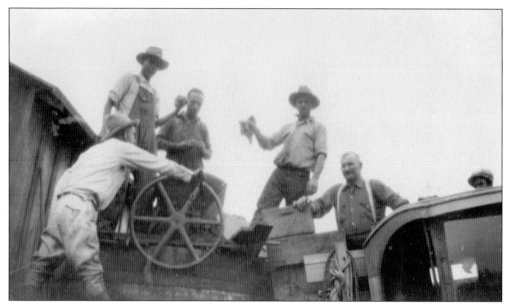

This photographs shows Camillo (far right), his friends, and a work crew crushing grapes. Camillo enjoyed the wine business. Every morning, before going out to the vineyard, he would have a glass of white wine with a raw egg in it. Later, he would come in along with the rest of the ranch hands for a hearty lunch that Luiccia would cook for everyone. Camillo was partial to two grape varietals: Barbera and Sauterne. His Barbera produced a rich red wine, and his Sauterne produced a dry white wine. When Camillo pruned his vines, he quenched his thirst from a half-gallon jug of wine, wrapped in burlap, that waited at the end of each row of vines. (Courtesy of Ernesto Pavese.)

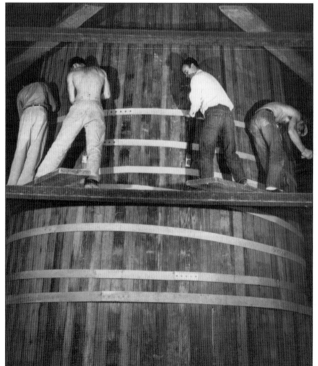

Camillo had six 15,000-gallon redwood tanks in the winery. He would keep wine for three full years before he sold a drop. Every year, he would filter one tank of wine and move it to the next tank. After the third year, the wine was bottled and ready to drink. (Courtesy of Ernesto Pavese.)

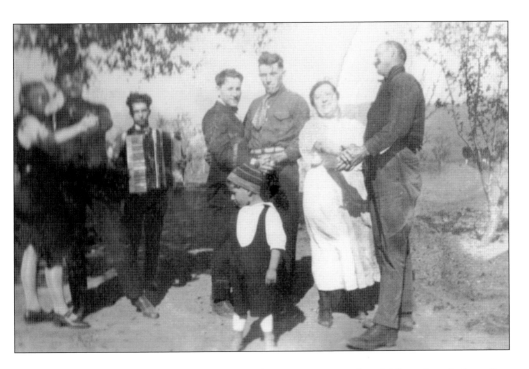

Camillo and Luiccia loved to entertain and had parties every weekend. Their friends from San Francisco would come down to Morgan Hill and dance to music played by a live band that would set up in the warehouse. Luiccia would cook for everyone and made Italian favorites like ravioli and gnocchi. There was always plenty of good wine. Above, Camillo and Luiccia are dancing together at far right. (Both, courtesy of Ernesto Pavese.)

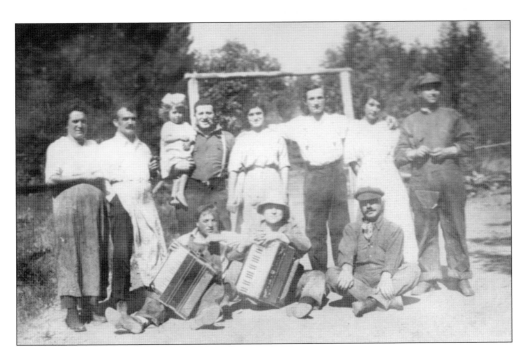

Camillo would say to his grandson, "Ernesto, I need 24 sparrows. If you shoot them in the head, I will give you another bullet. If you shoot them in the body, I will take two bullets away from you." Ernesto was only 12 when he used a .22 single-shot Remington to shoot the sparrows or a young jack rabbit that were put into a stufato, an Italian gravy to be poured over pasta. In this photograph, Ernesto sits next to his grandmother Luiccia with Camillo to the left and his aunt Eda to the right, in 1935. (Courtesy of Ernesto Pavese.)

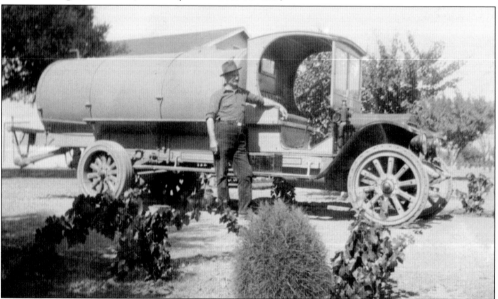

Henry Hecker, a Santa Clara County supervisor, asked Camillo if he had an extra man that could drive a water wagon to water the gravel side roads in order to keep the dust down. Camillo kept one man busy, full time, driving around and watering down the roads. In 1928, Henry Hecker realized his lifelong dream of connecting Gilroy to the coast, with a new highway over Gilroy's western range. This highway is named Highway 152, or Hecker Pass Highway. (Courtesy of Ernesto Pavese.)

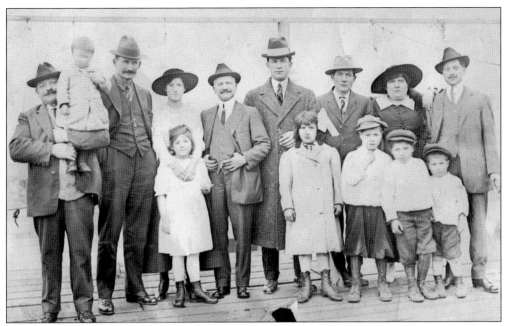

Many immigrants from the Piemonte region of Italy were drawn to Santa Clara Valley for its rich soil and mild climate, which reminded them of their homeland. They formed the Piemonte Club and would get together for picnics and barbeques at Oakdale Park along Watsonville Road in Gilroy. Here is a small group photograph of the Piemonte Club in the 1920s; Camillo is third from the left. Camillo always said, "Respect your friends and stay close to your family." (Courtesy of Ernesto Pavese.)

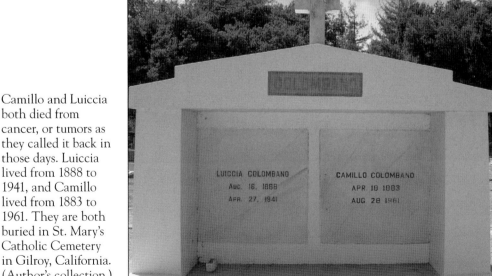

Camillo and Luiccia both died from cancer, or tumors as they called it back in those days. Luiccia lived from 1888 to 1941, and Camillo lived from 1883 to 1961. They are both buried in St. Mary's Catholic Cemetery in Gilroy, California. (Author's collection.)

Fortunato Pedrizzetti, born in 1872 in Taino, Italy, immigrated to the United States in 1903 with his wife, Louisa, and their young son John. The family eventually settled in San Martin, where there was good farmland. Fortunato died in 1929 at the age of 57 when his arm was severed in a farming accident. He is buried at St. Mary's Cemetery in Gilroy, California. (Courtesy of the Pedrizzetti family.)

Fortunato Pedrizzetti's son John was born in Taino, Italy, in 1898 and immigrated to the United States in 1903. At age 28, John married Eda Moissio-Maggiora, only 16, and together they had one child, Eddie Pedrizzetti. It was unusual during those days to have only one child, but as Eda always explained, one child was enough. Although everyone called him Ed, his birth certificate, dated October 23, 1927, named him "Eddie." Eddie's mother did not trust hospitals, fearing that her child would get mixed up, so Eddie was born at home on Seymour Avenue in San Martin. He graduated from Live Oak High School in 1945, just before World War II ended. Pictured here are Eddie and his mother, Eda. (Courtesy of the Pedrizzetti family.)

John Pedrizzetti purchased the Colombano Winery in 1945 when his good friend Camillo Colombano retired. John put in a truck scale certified by the state, so that the grapes grown on the property could be weighed and verified. Each ton of grapes produced approximately 160 gallons of wine. If a winery produced more gallons than tonnage, the Bureau of Alcohol, Tobacco, and Firearms (ATF) would investigate. Whoever weighed the trucks had to have a weighmaster certificate. The scale house is the small white structure in this photograph. (Courtesy of the Pedrizzetti family.)

The Pedrizzetti vineyard was planted of mostly red grape varietals. Along with Barbera, their signature grape varietal, brought over from rootstock from Italy in 1919, they planted Merlot, Zinfandel, Mission, and Matero (not a fine wine varietal but a good producer). The white varietals included Semillion, Golden Chaselais (usually used for sherry or other fortified wines), Pinot Blanc, and Green Hungarian. John and his son Ed used a tractor to cultivate their 65 acres of vineyards. All the vines were head-pruned, not trellised. Irrigation was done by a sprinkler pipe moved row by row by hand. (Courtesy of the Pedrizzetti family.)

The vineyard produced about 275 tons a year. At first, John Pedrizzetti did not produce any wine under his own label, instead selling his grapes to other wineries for the production of their wine. John would deliver his grapes to wineries like Paul Masson and Sebastiani, which bought all of John's Barbera grapes. Any leftover grape crop was picked and put into 40-pound boxes and sold by the roadside. John Pedrizzetti planted mustard or vetch (high in nitrogen) between the rows of his grapevines. (Courtesy of the Pedrizzetti family.)

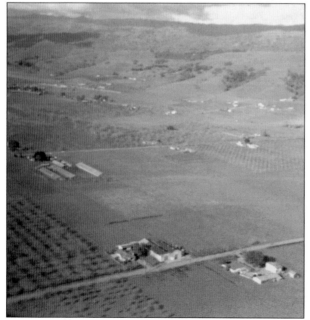

This is an aerial view of the Pedrizzetti Winery and homes: the home of John and Eda Pedrizzetti is shown bottom right and their son and daughter-in-law's (Ed and Phyllis Pedrizzetti) home and winery is seen across the street, to the left. (Courtesy of the Pedrizzetti family.)

In 1948, Ed Pedrizzetti first saw Phyllis Smith at a dance in Gilroy and was immediately smitten by her. They finally met when he drove by Phyllis and her friends walking in downtown Gilroy and offered them a ride. Phyllis says, "It was love at first sight and we never missed a night seeing each other until we married on March 5, 1949. Eddie was 21 and I was 20. One of those true love matches, we lived and worked together 24/7. We lived in the same house for 57 years until we sold the winery and retired to Montana. We had just celebrated our 62nd wedding anniversary when Eddie passed away on March 25, 2011." Here is Eddie and Phyllis's wedding photograph, taken in Reno, Nevada. (Courtesy of the Pedrizzetti family.)

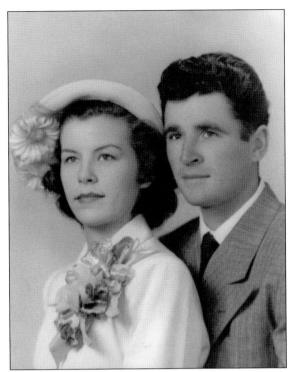

Ed and Phyllis Pedrizzetti had three children: Daniel "Danny," Kathleen "Kathy," and Jane "Janey." As soon as they were old enough, the three children helped in the winery by picking grapes and lugging and stacking crates. Here is the family at Christmastime in 1959; Ed, Phyllis, Kathy, and Danny are on the floor, and Janey sits on her mother's lap. (Courtesy of the Pedrizzetti family.)

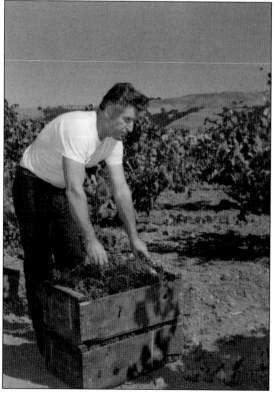

In 1968, John Pedrizzetti retired and gift-deeded the winery over to his son, Ed, and his wife, Phyllis. Ed would drive his delivery truck, seen in this photograph, to San Francisco every Saturday to deliver wine that was preordered on postcards. Customers would check a box and note the amount of cases needed. Ed's children have fond memories of tagging along with their father to make deliveries all over the city, while Phyllis stayed home to take care of the tasting room. In 1968, Ed and Phyllis opened a tasting room on Burnett Avenue in Morgan Hill, and they discontinued home deliveries the following year. From then on, all sales were either shipped or done out of the tasting room. (Courtesy of the Pedrizzetti family.)

Ed worked so hard picking grapes and lifting 40-pound lug boxes that by the end of the day his arms were completely fatigued and he would need Phyllis's help to get his shirt off. (Courtesy of the Pedrizzetti family.)

Here is Ed at the Pedrizzetti's first bottling machine. The machine filled five one-gallon jugs at a time, averaging 1,200 to 1,600 jugs per day, each jug weighing 12 pounds. Ed's father, John Pedrizzetti, never wanted to bottle varietals—to him, wine was either red or it was white. Also, the recordkeeping was more complicated for varietals. So, he only produced and bottled Burgundy, Chablis, and Vin Rose by the gallon. When Ed and Phyllis took over the winery, they produced Barbera and Zinfandel by the gallon. They also started selling their wine under their own label. These photographs were taken in the early 1970s when Ed was in his early 40s. (Courtesy of the Pedrizzetti family.)

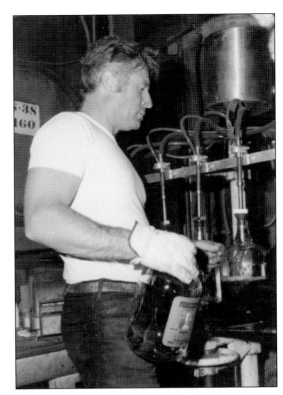

Although Phyllis had never tasted wine until she met Ed Pedrizzetti, she worked right alongside Ed in his family's business. Phyllis designed the wine labels and managed the tasting room, all while raising their three children. In 1976, Phyllis became the first female president of the Greater Santa Clara Valley Wine Growers Association, founded in 1946. Phyllis was also one of the main judges of the Orange County Fair Wine Competition for 31 consecutive years. (Courtesy of the Pedrizzetti family.)

On February 26, 1996, the winery was burned to the ground in a three-alarm fire, started in a portable kitchen that was set up in the warehouse. The Pedrizzetti family, along with Chef Giancarlo from Giancarlo's Italian Restaurant in Morgan Hill, were preparing a sit-down dinner for 65 guests when a propane leak found its way into one of the sterno tanks and exploded. Even though Ed Pedrizzetti had always warned them, "Don't ever have a party in the warehouse," he was one of the cooks that very night. As the fire consumed the winery, Ed drove through the roaring flames on one of his prized forklifts in order to save it. (Courtesy of the Pedrizzetti family.)

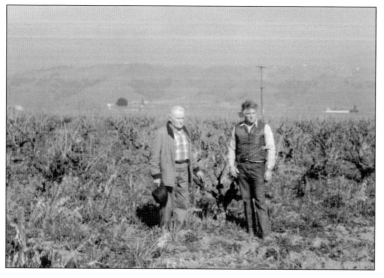

This photograph is of John Pedrizzetti and his son, Ed, walking the vineyards during the winter sometime in the early 1990s. Ed was frequently seen wearing his favorite vest. John Pedrizzetti passed away in 1995 at the age of 92, a year after his beloved wife, Eda, passed away. (Courtesy of the Pedrizzetti family.)

In 2006, Ed and Phyllis sold the winery and retired to their dream home in Jackson, Montana, where Ed enjoyed hunting, fishing, flying his airplane, and always drinking a good glass of Barbera wine. Ed died unexpectedly from complications after heart surgery on March 25, 2011, at the age of 84. (Courtesy of the Pedrizzetti family.)

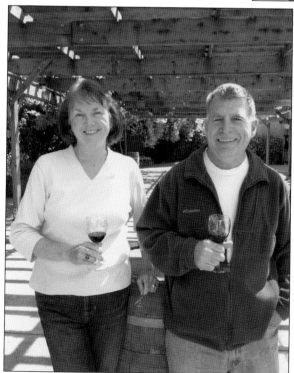

Mike and Maryclaire Sampognaro purchased the Pedrizzetti's home and winery in 2006. Just retired from their high-tech careers in Silicon Valley, the Sampognaros were ready for a change. They replanted vines and took advantage of the large-capacity tanks and bottling line that came with the winery in order to process wine for other local wine growers. Mike and Maryclaire are proud members of the Wineries of Santa Clara Valley Association, with Mike taking a turn as president and vice president over the years. In 2014, Mike helped spearhead efforts to install Wine Trail signage along the route of the local wineries in the region. (Author's collection.)

In 2006, after purchasing the winery and surrounding home from the Pedrizzettis, Mike and Maryclaire Sampognaro renamed the winery Morgan Hill Cellars. (Courtesy of Maryclaire and Mike Sampognaro.)

Eight

KIRIGIN CELLARS

Pietro Bonesio was born into a winemaking family in 1877 in Cardona, Italy, where he learned to make wine from his father, Giovanni. In 1903, Pietro came to the United States with his wife, Massimina, and worked his way west, taking on construction and farming jobs. In 1916, he fell back on what he knew best, starting Uvas Winery on a piece of land called Rancho de Solis in Gilroy. And for the next 60 years, Pietro's 500-acre ranch and winery stayed in his family.

In 1932, Pietro turned the day-to-day business operations over to his three sons, Louis, Victor, and Charlie. The winery was renamed Bonesio Brothers. The vineyard produced a number of varietals, including Zinfandel, Grignolino, Grenache, French Colombard, Golden Chasselas, and Sauvignon Vert.

When the Bonesios retired in 1976, they sold the winery to Nikola Kirigin-Chargin, a winemaker from Croatia with degrees in chemistry and enology. Nikola abhorred wine snobbery and professed that good wine should always be affordable. Nikola renamed the winery Kirigin Cellars and made high-quality wine until he too retired and sold the winery.

The current owner, Dhruv Khanna, purchased the winery in 2000 and went to work transforming the 48.5 acres of vineyards and grounds into one of the most beautiful destination wineries in the region. Dhruv added a magnificent event center, rustic and elegant all at once; a professional cricket field; a gazebo for wedding nuptials; a 130-space parking lot; and charging stations for electric vehicles.

In keeping with the traditions of the families before him, Dhruv keeps a strong focus on quality wines at reasonable prices. All of the wine produced by Kirigin Cellars is from grapes that are grown on the property, harvested by hand, aged, and bottled by the cellar's bottling line. And wine tasting is free, a rarity among wineries.

Each year, thousands of visitors come to Kirigin Cellars for wine tasting, picnics, weddings, dog and car shows, and numerous sporting events. Kirigin Cellars will soon be turned over to Dhruv's two grown daughters, who will ensure that the legacy of their family-owned winery will continue through the end of this century and beyond.

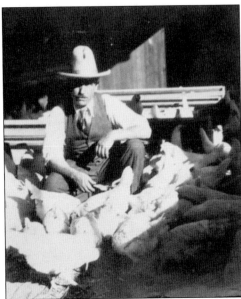

Giovanni Bonesio started a wine business in the town of Cordona in Piemonte, Italy, in 1847. In 1877, Giovanni's son Pietro Fidele Bonesio was born. Giovanni taught his son everything there was to know about the fine art of winemaking. This early wine education served Pietro well, becoming his livelihood after he immigrated to America. This photograph is of Pietro, surrounded by chickens, around 1900. (Courtesy of Joanne Bonesio-Hall.)

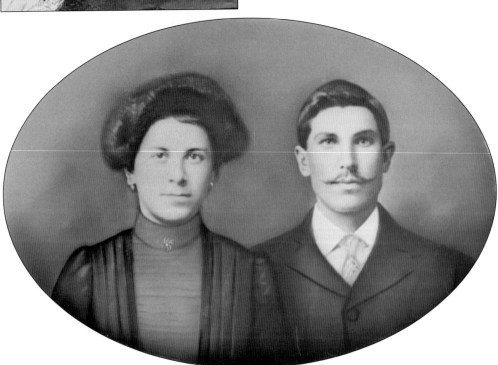

This is a photograph of Pietro and Massimina Bonesio taken in 1901, shortly after their marriage. On January 21, 1903, the newlyweds departed from Genoa on the SS *Montserrat*, and three weeks later the ship arrived at Ellis Island on February 13, 1903. Initially, Pietro worked in subway construction in New York City. Working his way west, he later farmed in Louisiana and then moved to Oakland, California, where he found work in the concrete business. In 1915, Pietro reverted to the traditional family occupation of making wine and started Uvas Winery in the Rucker District, north of Gilroy, and then moved to the present location on Rancho de Solis in Uvas Valley. (Courtesy of Joanne Bonesio-Hall.)

This photograph, taken around 1913, is of Pietro holding the hand of his young son Louis. Along with his brothers, Louis, about four years old here, grew up and eventually took over the ranch and winery. It was Louis's future daughter Joanne who supplied all of the photographs of the Bonesio family. (Courtesy of Joanne Bonesio-Hall.)

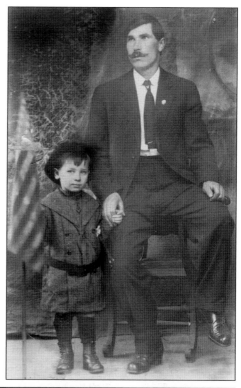

Here is an early photograph of the Bonesio family around 1920. Although Pietro and Massimina had five children, it appears that their oldest daughter, Ermenia, was not included in this photograph because she was married at the time. From left to right are (seated) Pietro, Victor, and Massimina; (standing) Charles, Marie, and Louis. (Courtesy of Joanne Bonesio-Hall.)

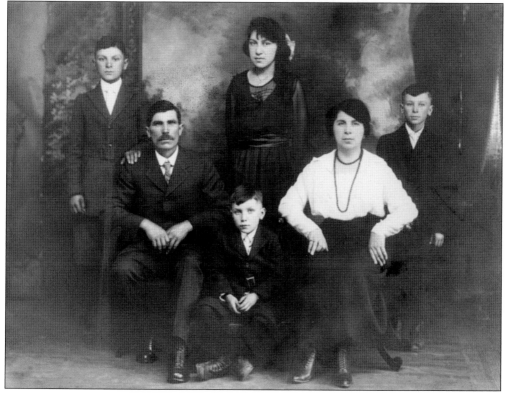

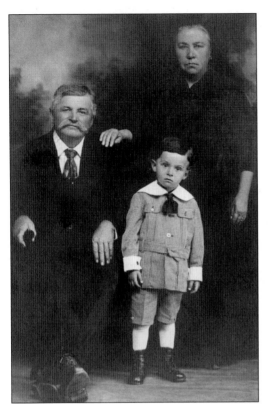

Massimina's parents, Vito and Angelina Ferrarino, are shown here in this photograph dated June 14, 1920. This unidentified child must have been one of their grandchildren. After Vito died, and perhaps to signify mourning, Angelina always wore black. Angelina also wore several aprons at the same time, stripping them off one at a time as they became soiled. She could always be found in the kitchen chopping garlic or parsley, helping to feed all the hired help that worked on the ranch. (Courtesy of Joanne Bonesio-Hall.)

Pietro and Massimina's five children are shown here from left to right: Charles Bonesio, Marie Bonesio-Bonelli, Victor Bonesio, Ermenia Bonesio-Scagliotti-Schick, and Louis Bonesio. This photograph was taken some time in the late 1920s. The five siblings are standing inside of one of two heart-shaped cement forms that their father, Pietro, had built in the yard. (Courtesy of Joanne Bonesio-Hall.)

Pietro Bonesio's son Louis Bonesio Sr. (1909–2001) married Merle Brown Bonesio (1913–1992) in October 1932. With 200 guests, the wedding was the largest that the "Little Brown" Presbyterian Church of San Martin had ever had. Merle was a gifted tailor and sewed her wedding gown and matching hat. Louis and Merle had a long and happy marriage of almost 60 years. Standing up behind the newlyweds is Merle's sister Ruby Alamand and Louis's brother Charlie Bonesio. (Courtesy of Joanne Bonesio-Hall.)

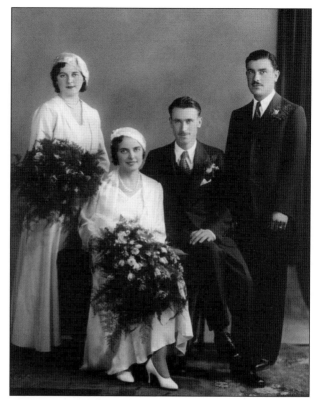

Merle Bonesio stands beside her son Louis Jr. as he sits atop a pony around 1933. Louis Jr. had beautiful pale blue eyes from the time he was a baby. Louis Jr. made medical history when he became the first person to receive primary organs from two different donors. In May 1974, he received a heart transplant at Stanford, and in 1984, he received a kidney transplant at the University of California, San Francisco. (Courtesy of Joanne Bonesio-Hall.)

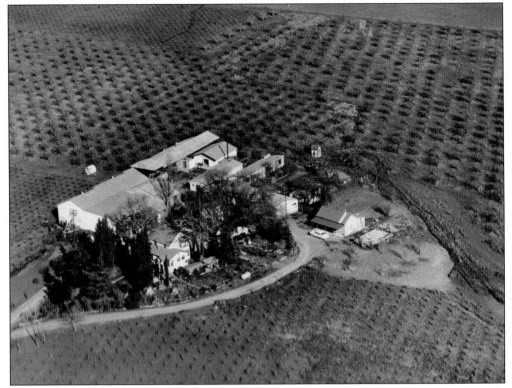

This aerial photograph shows the Bonesio family compound, comprising the multi-sectioned family home, the winery, and an extra home for the hired help. One hundred years earlier, this property had been home to a Mexican revolutionary leader named Joaquin Solis, who named it Rancho de Solis. The main home is one of the oldest wooden structures in Santa Clara County, dating back to 1833. Redwood timbers for the house had been hauled from Mount Madonna, which was part of the land empire owned by cattle baron Henry Miller. (Courtesy of Joanne Bonesio-Hall.)

Merle and Louis Bonesio Sr.'s two children, Joanne and Louis Jr., are shown here in the summer of 1938. Joanne is pointing toward the ripening peaches on a nearby tree. The children are standing in front of one of two fishponds that Pietro, their grandfather, made out of abalone shells. Joanne remembers how the pond's cascading waterfall used to shimmer off the colorful shells. Pietro was a prolific builder, surrounding the outside of his home with many rock and stone structures, including a bread oven, a barbecue pit with a stove, an outside sink with running water, and fishponds filled with goldfish. (Courtesy of Joanne Bonesio-Hall.)

The large two-story house had three sections to accommodate several families. Pietro and Massimina lived in one section of the house, and their sons and families lived in the other two sections. The house had 22 rooms, including a 700-square-foot ballroom, a library, a sunroom, three separate kitchens, and many bedrooms. Four generations of the Bonesio family lived here, and this historical home still stands today. (Courtesy of Joanne Bonesio-Hall.)

One of Pietro Bonesio's more unusual structures was a concrete table with a mulberry tree planted in the center. Pietro's friends frequently chided him that the tree would grow and eventually split the table in two. He responded, "I'll be dead by that time." However, the tree did split the table in 1964, and Pietro passed away in 1966 at the age of 89. Rebecca Morris, the first and only telephone operator in San Martin at the time, is seated to the left. Pietro's daughter-in-law Merle Bonesio is seated on the mushroom stool at right. (Courtesy of Joanne Bonesio-Hall.)

Pietro loved his family and invited them over every Sunday for dinner and other special events. He was very skilled at the barbeque, often cooking up chicken halves while Massimina fixed the rest of the side dishes. Here is Pietro at his legendary homemade stone barbeque. (Courtesy of Joanne Bonesio-Hall.)

Whenever the weather permitted, Sunday dinners were held outside under the grape arbor for up to 30 friends and family. The table was always set with an embroidered tablecloth, fine china, silverware, and glassware. Plenty of delicious food included Massimina's homemade ravioli and gnocchi and Pietro's delectable barbequed chicken. After dinner, everyone played games, either Pedro, a trick-taking card game, or Morra, a hand game (dating back to the ancient Romans) that was played with fingers hitting the table and people calling out a numbered guess. Great hilarity ensued. In this photograph, taken around 1948, Massimina and Pietro are seated at the head of the table and their son Louis Sr. and his wife, Merle, were seated at the other end (bottom left and right). (Courtesy of Joanne Bonesio-Hall.)

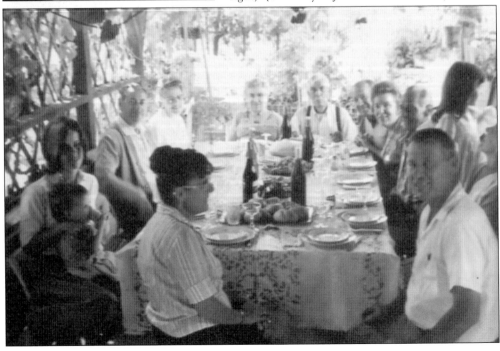

Here is Pietro inspecting his vineyards, which included Zinfandel, Grignolino, Grenache, French Colombard, Golden Chasselas, and Sauvignon Vert. Although Pietro still retained ownership of the winery, in 1932 he turned the day-to-day business operations over to his three sons, Louis, Victor, and Charlie, and Uvas Winery was renamed Bonesio Brothers. After Charlie passed away from tuberculosis, Louis and Victor split the ownership of the winery. Louis kept the winery and half the vineyard, and Victor took the other half of the vineyard and a liquor store. (Courtesy of Joanne Bonesio-Hall.)

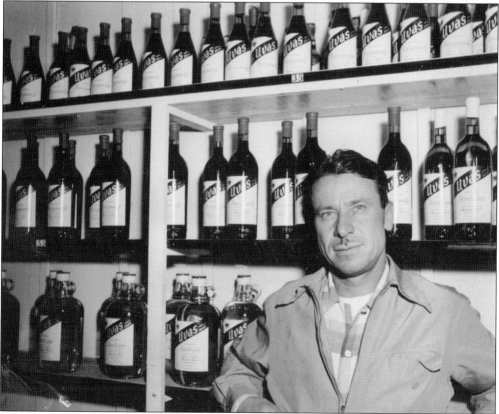

In this photograph, Louis Sr. Bonesio stands before shelves of his wine bearing the Uvas brand label in two sizes: fifths and gallons. All of the Bonesio wines were made from estate-grown grapes, and customers had three choices: red, white, or rose. The red wine was called burgundy and was full bodied, made mostly from Zinfandel grapes and mixed with claret (another blend of red grapes). The white wine was called sauterne and was made mostly from Golden Chasselas and other grapes. The rose was made from Grignolino grapes. (Courtesy of Joanne Bonesio-Hall.)

In the early days of the wine industry, wineries did not have tasting rooms, but instead they had sales rooms. Louis Jr., who inherited the gift of building from his grandfather, Pietro, constructed the entryway to the sales room in the shape of a wine barrel. To this day, visitors from all walks of life, including the author, come to the winery and have their photograph taken in front of it. (Courtesy of Joanne Bonesio-Hall.)

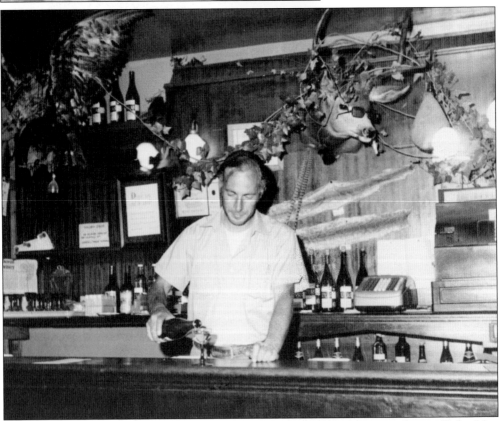

The Bonesio Winery's tasting room, pictured here, had an eclectic decor, with a stuffed golden eagle, skins taken off captured snakes from the vineyard, and a deer head overlooking all kinds of bottled wine lined up on the counter. Louis Jr., who helped in the sales room, is seen here pouring a glass of wine. Like his father before him and his son after him, Louis Jr. was a clamper for E Clampus Vitus, and he served as president of the organization's Mountain Charlie Chapter 1850. Louis Jr. was survived by his son Louis I. Bonesio III and daughter Therese when he passed away on February 6, 1994. (Courtesy of Joanne Bonesio-Hall.)

When Louis Sr. took over the winery, he kept the Uvas brand intact but changed the wine label to his name, Louis Bonesio. (Courtesy of Joanne Bonesio-Hall.)

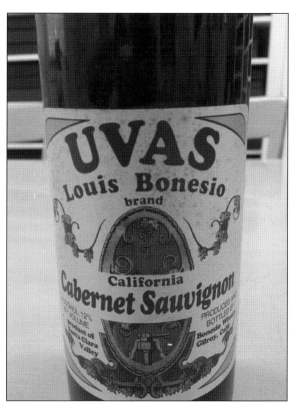

In an effort to add sizzle to an advertising campaign for the local wine industry, an unidentified, long-legged model admires the grapevines growing on the Bonesio ranch property. Louis Bonesio Sr. is standing beside her. This photograph was taken in the early 1960s. (Courtesy of Joanne Bonesio-Hall).

This photograph was taken at Pietro and Massimina's 50th wedding anniversary celebration in 1951. There were 350 in attendance at the sit-down dinner that was held at the hall inside St. Mary's Catholic Church in Gilroy. Here, Pietro and Massimina are surrounded by their children. From left to right are Louis Sr. (light-colored suit), Ermenia Bonesio-Schick, Pietro, Massimina, Marie Bonesio-Bonelli, and Victor Bonesio. Pietro and Massimina went on to celebrate their 60th anniversary as well. Pietro passed away in 1966 at the age of 89, and Massimina passed away in 1977 at the age of 93. (Courtesy of Joanne Bonesio-Hall.)

In 1976, and after 50 years of ownership, the Bonesio family sold their winery to Nikola Kirigin-Chargin, whose family had been winemakers in Croatia. A graduate of the University of Zagreb in chemistry and enology, Nikola came to the United States in 1959 with his wife and three sons and quickly found work in the wine industry. During the 1960s, he became chief enologist and chemist for the San Martin Winery and later for Almaden Vineyards. Nikola abhorred wine snobbery and was known to say that people should boycott expensive wines. When Nikola was 84, he was ready to retire and sold his winery to Dhruv Khanna. (Courtesy of Dhruv Khanna.)

Gambino Romero, cellar master, was 27 years old when he was hired in 1974 by the Bonesio family and continued working for the winery when it was sold to Nikola Kirigin and then to Dhruv Khanna. Gambino continues to take expert care of the vineyards, warehouse, and cellars to this day. (Author's collection.)

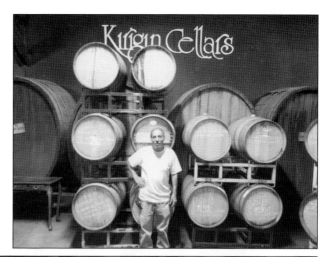

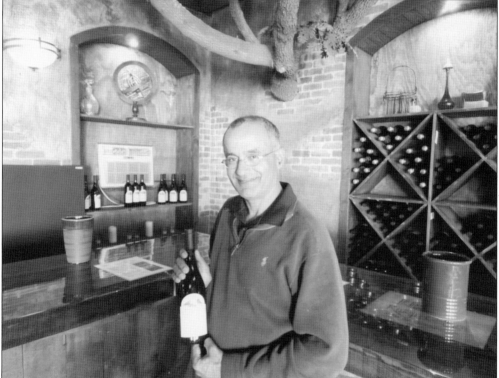

In 2000, the winery was purchased by Dhruv Khanna, general counsel and cofounder of Covad Communications. From New Delhi, India, and a graduate of Stanford Law School, Dhruv is an avid cricket fan. While searching for a suitable plot of land to hold cricket events, Dhruv came upon the Kirigin estate, which was up for sale. Since purchasing the historical 48.5-acre property, Dhruv has transformed it into a breathtaking destination winery. A newly built Tuscan-style clubhouse is situated among 33 acres of rolling vineyards. Kirigin Cellars handcrafts small batches of wine produced from 11 different wine grapes, including the rare varietal Malvasia Bianca, an aromatic white wine and best-in-class award winner. Dhruv is pictured here inside the 1916 tasting room, one of three tasting rooms on the property, holding one of his best-selling wines, Vino de Mocca. (Author's collection.)

Discover Thousands of Local History Books
Featuring Millions of Vintage Images

Arcadia Publishing, the leading local history publisher in the United States, is committed to making history accessible and meaningful through publishing books that celebrate and preserve the heritage of America's people and places.

Find more books like this at
www.arcadiapublishing.com

Search for your hometown history, your old stomping grounds, and even your favorite sports team.